IMAGES
of America

HIGH POINT

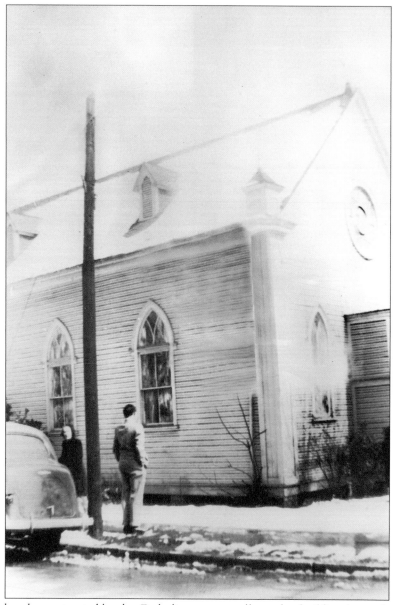

The first church constructed by the Catholics was a small wooden building located at 701 East Green Street. It was named St. Edwards in honor of Edward McCarthy, who donated the land. Fr. Gregory Windshiegl constructed the new building for $600. It was dedicated on September 29, 1907. Some funds were raised by soliciting Belmont Abbey graduates named Edward. (Courtesy of Immaculate Heart of Mary Church.)

ON THE COVER: Harry Raymond (first row, left), a colorful character, moved to High Point and started a company around 1910 that wholesaled veneers. In addition to his home at 1009 North Main Street, he built a lodge where he could enjoy company. The man second from the right on the bottom is Jack Dempsey, the famous boxer. (Courtesy High Point Museum.)

IMAGES
of America

HIGH POINT

Barbara E. Taylor

ARCADIA
PUBLISHING

Published by Arcadia Publishing
Charleston, South Carolina

Printed in the United States of America

Library of Congress Control Number: 2012955161

For all general information, please contact Arcadia Publishing:
Telephone 843-853-2070
Fax 843-853-0044
E-mail sales@arcadiapublishing.com
For customer service and orders:
Toll-Free 1-888-313-2665

Visit us on the Internet at www.arcadiapublishing.com

To all those who enjoy unfolding the stories of our past.

CONTENTS

Acknowledgments 6

Introduction 7

1. How We Worked 9

2. How We Played 41

3. How We Learned 59

4. How We Worshipped 77

5. How We Celebrated 89

6. Who We Are 105

ACKNOWLEDGMENTS

When I started this project, I was concerned that there would not be enough photographs. Fortunately, local historian Mary Lib Joyce gave a photograph collection to the library, many of which had never been published. Individuals as well as organizations contributed others. I hope that the images selected will bring new insight to readers.

I wish to thank the staff of the High Point Public Library Heritage Room for allowing me to cull through Mary Lib Joyce's collection. These photographs were the foundation of the book. A very big thank-you to Larry Cates, Stephan Rantz, and Karen Hardie, who pulled files, showed me books, helped me locate obscure information, and unraveled some mysteries. I also wish to thank the staff at the High Point Museum who shared with me many images in their collection. Special thanks go to Marian Inabinett, curator, and Corinne Midgett, registrar, for their physical help and to Edith Brady, director, for giving me permission to use images.

I am indebted to Anne Andrews, who shared with me many stories of High Point, as she reviewed the photographs, edited the text, and helped lead me to other resources. Mary Browning, another fellow historian, also shared her ideas and, again, willingly edited the text. Although having lived here for 12 years, I am still a relative newcomer, and I learned much from those who grew up here and the stories they shared with me.

Finally, my deepest appreciation goes to the Hayden-Harman Foundation, Phoebe and Pat Harman, Patrick and Susan Harman, who supported me in this endeavor. Not only do I consider them friends, I admire them for all the good work they have done for High Point. Without their assistance, I would not have been able to complete the book.

The majority of the images are courtesy Mary Lib Joyce and Joe E. Brown files, Heritage Research Center, High Point Public Library. All other images have been credited accordingly.

INTRODUCTION

Long before our early European ancestors settled here, Native Americans, known as the Sauras, roamed the land. In the mid-1750s, Quakers began to settle in the area, establishing several meetings, including Deep River and Springfield. Farms of 300 and 400 acres were being acquired and worked by such individuals as Phillip Hoggatt and, later, John Haley.

The community grew slowly. By the early 1850s, a hotel was built in what would become the center of High Point, and in 1853, lots were being sold to future residents. It was the completion of the Plank Road to Salem in 1853 and the coming of the North Carolina Railroad in 1855 that inspired certain business-minded individuals to see a unique opportunity at the crossroads of the two thoroughfares.

The city of High Point was so named because it was the "highest point" on the surveyed rail line of the North Carolina Railroad. Thomas Sechrest, Solomon Kendall, and Nathan Johnson owned the land near that junction. Kendall sold land to Salem resident Francis Fries, who built a warehouse to serve both the wagons and trains loaded with goods and freight. Kendall also sold 11 acres to William Welch, north of Washington Street and east of Salem Street, which is known as Main Street. Welch immediately divided his land into lots that he advertised for sale, stating the location "promises to become one of the most thriving towns on the entire line of railroad." Welch also opened a general store.

When the town was incorporated on May 26, 1859, there were 595 people residing in the general area, including 70 slaves and 14 free black people. Then on July 28, 1859, Robert C. Lindsay was elected the chairman of the town's board of commissioners. Others appointed as commissioners were John Carter, Sewell Farlow, Eli Denny, and Jeremiah Piggott. John W. Lambeth was the town's first policeman.

On May 20, 1861, High Point's future suddenly shifted when North Carolina became the last state to secede from the Union. As a transportation center, High Point was a natural location for gathering and training troops. Early in the war, the state opened a training camp near the railroad, named for Col. Charles F. Fisher, a former president of the North Carolina Railroad, who was killed at the Battle of First Manassas (Bull Run).

During the war, High Point produced rifles, hats, shoes, ink, and much more. The railroad was used to ship soldiers and war goods where they were needed. High Point also provided a "wayside hospital." The Barbee Hotel was converted to a hospital, where over 5,700 soldiers were treated during the last two years of the war, even though High Point was a town of barely 600 people. Days before the end of the war, Capt. Adam Kramer, under the direction of Gen. George Stoneman, raided the area, burned the freight depot, and left the town in great disrepair.

After the war, High Point struggled to recoup its economy. Many of the farms were decimated. However, one of the area's abundant resources was timber. A Northern soldier, who had fought in the war and thought our weather pleasant, relocated to the South. William Henry Snow realized the abundance of persimmon and dogwood trees provided an opportunity. He began

to manufacture shuttle blocks for the Northern textile mills as well as wagon and buggy spokes and ax and hammer handles. Not content with his success, he patented several basket designs, including a tobacco basket, which was used universally. Snow also started the Modern Tobacco Barn Company and promoted a new way to grow tobacco that was adopted throughout the region. Snow sold his plant to his son-in-law, Jonathan Elwood Cox, who eventually produced 90 percent of the shuttle blocks in the world. Snow also operated a lumber mill that he passed onto his son Earnest A. Snow. *The Charlotte Chronicle* reported in 1887 that 500 workers were employed in the companies started by Snow.

Throughout the 1870s and 1880s, High Point was growing. Opportunity knocked for African American and white citizens alike. The earliest black-owned business in High Point was the public "hack" or cab driven by Major Gray. Another early African American businessman was Willis Hinton, who arrived in High Point in 1868. After working for the railroad, he found a job in Snow's factory until 1883, when he opened a café on South Main Street. Two years later, he sold the café and opened the 11-room Hinton Hotel on East Washington Street that he operated until his death in 1924.

In 1889, on a trip north, Earnest Snow noticed the sharp difference in price between raw lumber and finished products. In the rear office of the Jarrell Hotel, Snow met with John Tate and Thomas Wrenn to organize the High Point Furniture Company. Tate and Wrenn invested $3,000 each, almost their entire life savings. Snow furnished the lumber to build the factory and make the furniture. The plant opened in 1889 with a workforce of 25 to 50 men. The first piece they made was a desk for the company. It would only be a matter of time before High Point became the "Furniture Capital of the World."

In 1904, James H. Adams and J. Henry Millis began another major industry with the establishment of the High Point Hosiery Mill. Within 10 years, nine textile mills were located in High Point. By 1926, High Point was recognized as the "Hosiery Capital of the South."

From the 1920s through the 1960s, both textile and furniture industries sustained High Point's growth. Manufacturing was adapted during both world wars to serve the country by making wooden propellers for airplanes and socks for soldiers.

But High Point's business community grew more diverse. Beeson's Hardware (1883), *High Point Enterprise* (1884), High Point Telephone Exchange (1895; it later became North State Telephone Company in 1905 and North State Communications in the 21st century), Jarrett Stationary (1902), High Point Regional Hospital (1904), High Point Bank (1905), Marsh Kitchens (1907), and Thomas Built Buses (1916) are a few examples. To our traditional base of furniture and textile manufacturing, High Point has added distribution and warehousing, pharmaceuticals, and biotechnology. More than 70 internationally-based companies have year-round operations here, and the city hosts the world's largest home furnishings trade show twice a year with buyers from 112 countries making High Point North Carolina's "International City."

High Point's humble beginning at the intersection of the Plank Road and the railroad has led to over 150 years of entrepreneurial spirit and growth. Today, the city is home to a culturally rich, diverse population of more than 100,000 in the nation's 37th largest metro area with 1.6 million residents.

One

HOW WE WORKED

High Point was a rural area where people sustained themselves through farming, primarily growing what they needed. With the advent of the Plank Road and railroad, people began growing other crops for trade. The land was heavily wooded. After the Civil War, William Snow moved south to take advantage of the persimmon and dogwood trees, making spokes, handles, and shuttle blocks for textile manufacture. Many years later, his son would start the High Point Furniture Company, recognizing that a finished product, such as furniture, was more profitable than raw material.

High Pointers became leaders in the hosiery industry and furniture manufacturing. These industries created spin-off enterprises that supported them: Carolina Container shipped furniture in cardboard boxes, hardware companies manufactured drawer pulls and knobs, and dye works colored yarn, for example. As hosiery and furniture grew, so did the city and many businesses. In 1909, High Point began holding semiannual furniture markets. This market continues 100 years later and has helped High Point to become the "Home Furnishings Capital of the World" and the "International City of North Carolina".

Besides furniture and hosiery, High Point was home to many other industries. Trolley cars, buses, buggies, and boats were built in High Point. Some built trucks, while others hauled freight. Today, roads and interstates serve instead of the old Plank Road and railroad.

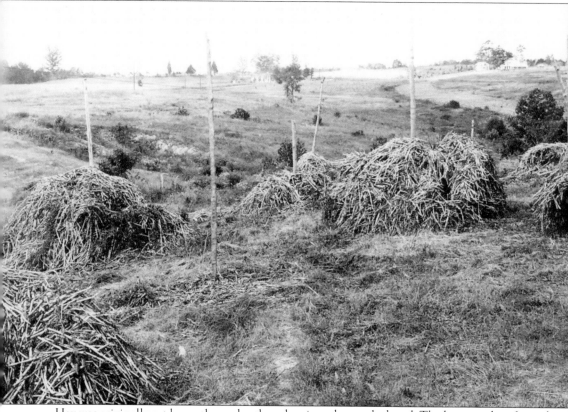

Hay was originally cut by scythe and gathered up into sheaves by hand. The hay was then formed into shocks (set up in a field with the butt ends down) in the field until it could be gathered up for storage. Later, horse-drawn implements, such as mowers and binders, did the haying.

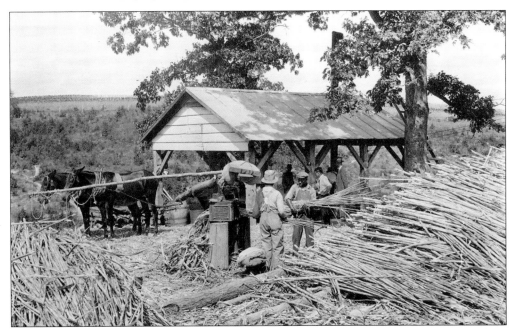

Sorghum was a moneymaking crop in the South before the Civil War. Though labor intensive, it was a good cash crop for the South that the North depended on. Sugar was an expensive commodity. Sorghum, on the other hand, grew just about everywhere, and pressing it to create sugar was something that could be done at home with a minimum amount of equipment.

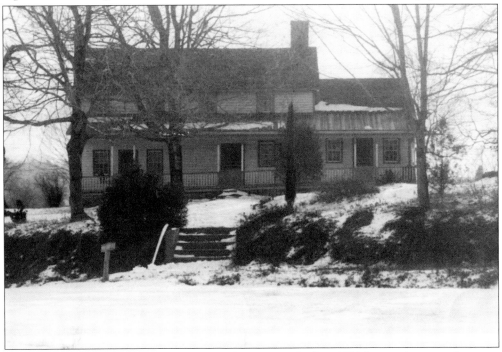

Brummell's Inn, located on West Lexington Avenue, was built in 1814. It served as an early tavern and stagecoach stop. It is located in Davidson County in a community that once was known as Pennfield and is now a private residence.

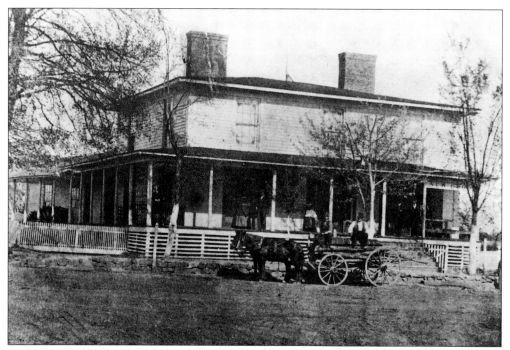

Noah Jarrell, older brother of Manliff, purchased the Hunt Hotel at South Main Street and East Commerce Street from Nathan Hunt, the first mayor of High Point. Noah operated a general store in connection with the hotel. At times, his hotel was known as Noah's Ark. His brother Manliff ran Jarrell's Hotel.

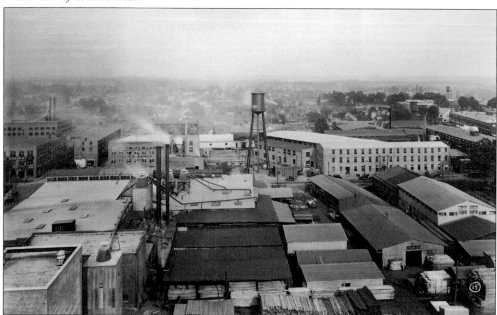

W.H. Snow began Snow Lumber Company in 1868. It made shuttle blocks, wagon and buggy spokes, and axe and hammer handles. When the initial plant burned, it was relocated on Hamilton Street. Snow's son-in-law J. Elwood Cox continued the business and, at one point, sold 90 percent of the world's shuttle blocks.

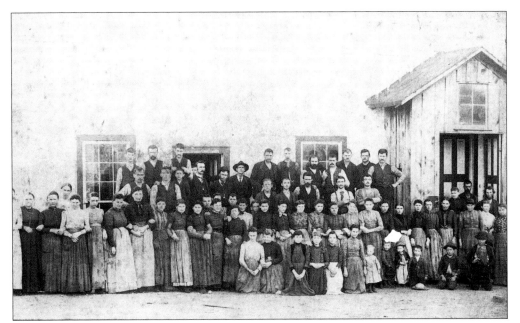

In 1879, O.S. Causey, W.H. Snow, and others built the Willowbrook Cotton Mills, the forerunner of the textile business in High Point. Unfortunately, it burned to the ground. Causey rebuilt the business in the 1880s as the Empire Plaid Mill. Before federal regulations were passed, children, as well as men and women, worked at the mill.

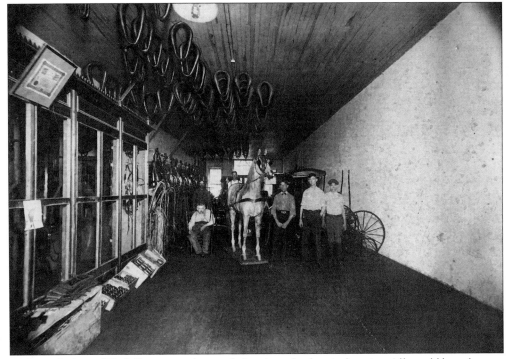

In the early days of High Point, people traveled on horseback or in buggies. All would have known the Francis J. Horney Livery Stable, as it provided collars and bridles and other necessities. Horney, a harness maker, owned this store at 27 North Main Street in 1902.

High Point Hosiery Mill was organized in 1904 by J. Henry Millis and John Hampton Adams and became the first successful hosiery business in High Point. As the company grew, it established the Highland Cotton Mills in 1913 and opened the Cloverdale Dye Works in 1927.

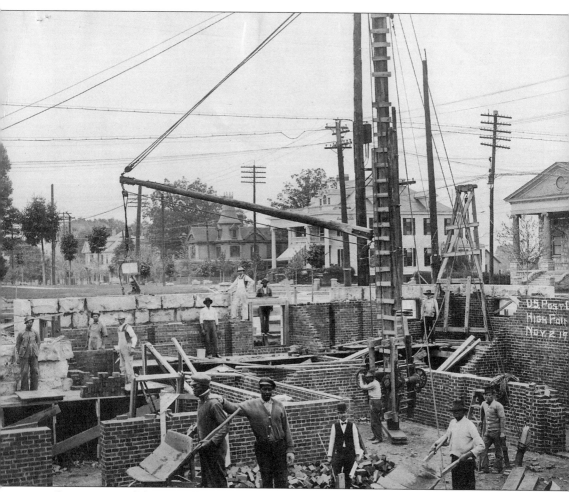

Construction of the post office was under way on November 2, 1910. Buildings located on Main Street are visible in the background, including, from left to right, the E.A. Snow Home (with tower); the C.A. Bencini Home, which became the Commercial Club; and the second Quaker meetinghouse constructed downtown.

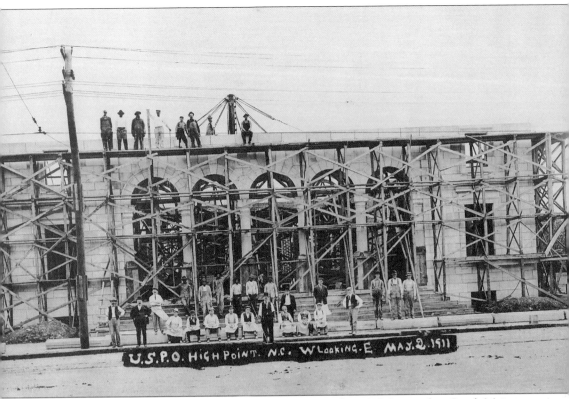

U.S.P.O. HIGH POINT. N.C. W. LOOKING. E. MAY. 2. 1911

Construction on the first federal building in High Point started in 1910. Located on South Main and Commerce Streets, it was built to accommodate the post office. It was one of the most attractive buildings in the city and served as the post office until 1933. In 1935, it was used as the city library for a short while.

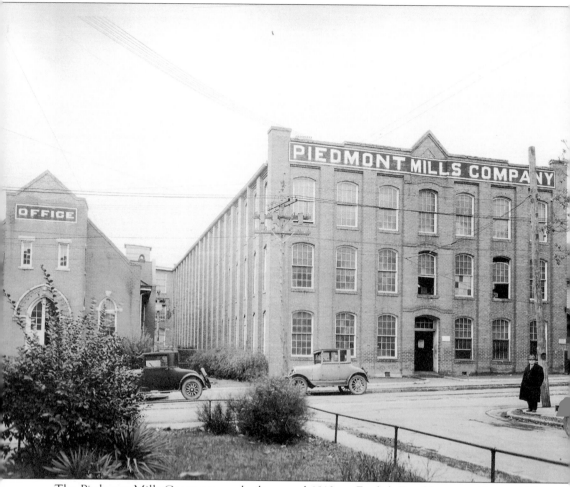

The Piedmont Mills Company was built around 1910 on English Road between Elm and Pine Streets. It was established by J. Henry Millis and John Hampton Adams. It was absorbed by Adams-Millis when that company was formed in 1927. Note that the office for the company is in what was once the Women's Memorial Evangelical Lutheran Church.

Several North State Telephone
Company linemen pose in front
of the National Bank of High
Point at 201 North Main Street.
The crew was dismantling the
main cable pole at the corner of
Main and Washington Streets,
near the central office building,
about 1918. (Courtesy North
State Communications.)

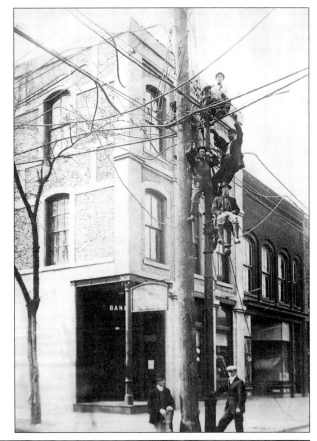

In 1919, the North State
Telephone Company purchased
a building on College Street
(now Hayden Place). This c. 1922
photograph shows the interior
of the commercial office. Jesse F.
Hayden, the general manager is
on the left, and A.A. Allred is
at the cashier's window. Hayden
led with imagination, inventing
the automatic busy signal. It was
the first company in the state to
provide dial service. (Courtesy
North State Communications.)

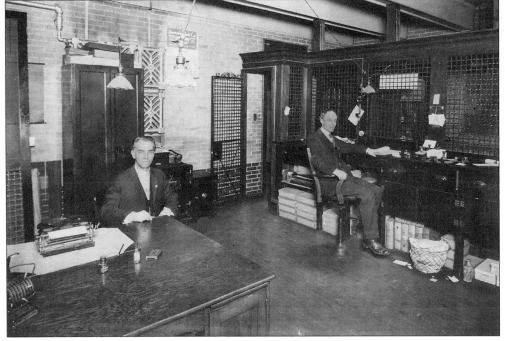

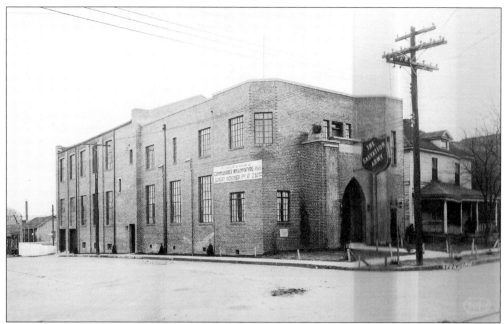

The Salvation Army first arrived in High Point sometime between 1913 and 1917 with their first location at 204 ½ North Main Street. By about 1929, it was located in this building at 801 South Main Street. The Salvation Army continues to serve the High Point community.

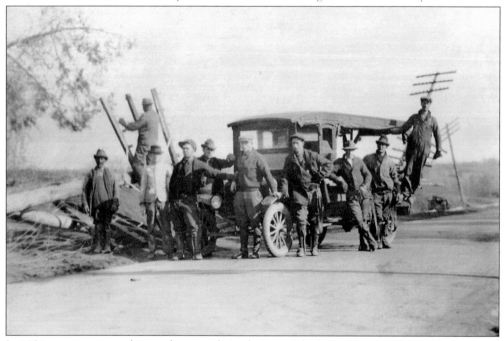

In 1924, a severe storm damaged many of North State Telephone Company's lines and poles in and around High Point. With service to Lexington, Thomasville, and Jamestown and toll lines to Winston-Salem, Randleman, and Asheboro, keeping the infrastructure intact was difficult. When efforts by Southern Bell to force North State out of business failed, the company became one of the premier independents in the country. (Courtesy North State Communications.)

Tomlinson Chair Company opened in 1890 on North Main Street, where it assembled, finished, and upholstered wood stock that was shipped from the North. In 1900, brothers C.F. Tomlinson and S.H. Tomlinson organized the company and built a plant on West High Street, seen here, between Elm and Dalton Streets. Additional buildings were added in 1906, 1911, and 1924. This industrial complex, one of the largest and most prominent in the city, included a notable chimney stack with the name Tomlinson spelled in brick. It also had a private water tower. A rail spur, loading yards, lumberyards, and a drying kiln enhanced the complex. In the 1920s, the company began manufacturing matched dining room sets and displayed their products in gallery settings, a new concept for the industry. After the company closed, the buildings were converted into a furniture design center.

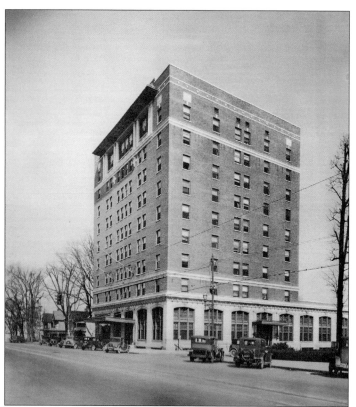

The Sheraton Hotel at 400 North Main Street was opened in 1921 at a cost of $700,000. It was designed by leading New York hotel architect W.L. Stoddard and had 10 floors and 130 rooms, some with private baths. It was the most impressive hotel in the city.

High Point City Hall was located on the corner of East Commerce and South Wrenn Streets. J.A. Jones Construction of Charlotte was awarded the bid for $167,000. It was first occupied in 1923 by housing city offices and the Paramount Theatre. It was razed in 1973 for the expansion of the Southern Furniture Exposition Building.

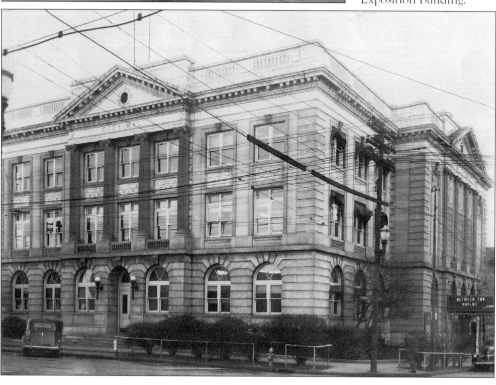

McEwen Lumber Company was founded in 1899 in Asheville, North Carolina, by Wooster McEwen. The headquarters was established in High Point in 1923, and by 1925, they had a lumberyard on English Street and West Point Avenue. In 1995, Hood Industries acquired McEwen and today operates as Hood Distribution/McEwen Group.

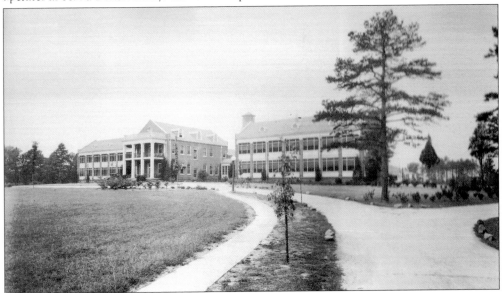

The Guilford County Tuberculosis Sanatorium opened on East Main Street of Jamestown (now Guilford Technical Community College) in 1924. Caesar Cone, a Greensboro industrialist who was recovering from tuberculosis, launched a drive to build this facility where those who had the disease could receive treatment. The gazebo, built in 1923 as a bus stop, is the only remaining vestige of the sanatorium.

The Haizlip Funeral Home was first located in a two-story house at 211 Taylor Street, which was also the Haizlip's home. It was opened in June 1924 by Louis Bernard Haizlip. Many black businesses of that time were operated out of the owners' homes. (Courtesy Haizlip family.)

The High Point, Thomasville & Denton Railroad was founded in 1924. O. Arthur Kirkman was secretary-treasurer and manager. The presence of the railroad heavily influenced the development of Commerce Street in High Point and facilitated the export of High Point's many products.

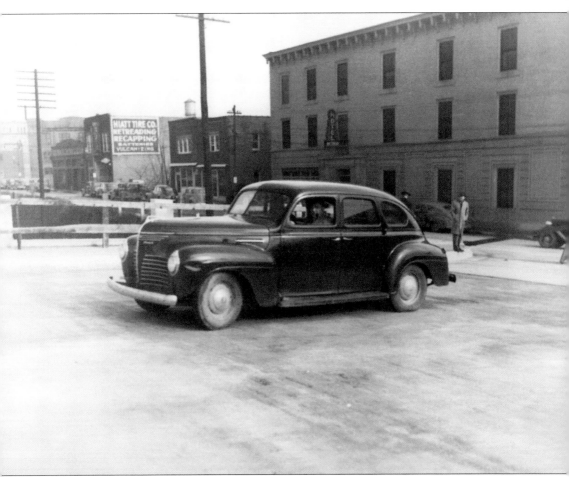

This 1941 Plymouth car is crossing the Elm Street Bridge at High Street. The Biltmore Hotel can be seen in the background as well as the Hiatt Tire Company and Dr. Max Rones's office. Today, the Natuzzi showroom stands on this southeast corner of High and Elm Streets (formerly Willowbrook).

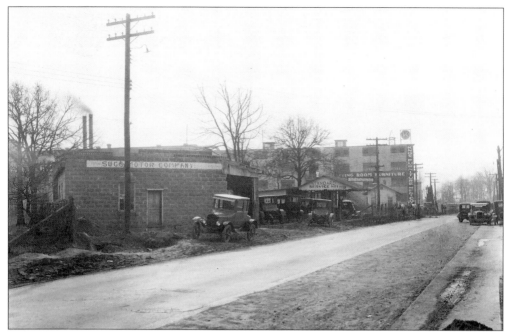

The 1929 city directory notes that the Knox Furniture Company was located at 1647 English Street, Standard Service No. 1 was at 1633, and Sugg Motor Company at 1629. Several restaurants, including Ideal Barbecue and Buck's Lunch, were across the street. All these businesses were located between West Point Avenue and Cecil Court.

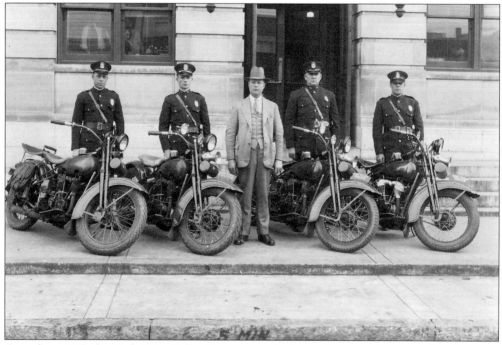

As early as 1927, the High Point Police Department had a small group of motorcycle policemen. They included Earl Dowdy, B.R. Lowe, Z.O. Dorsett, and J.O. Pike, shown here with the chief in front of city hall. Note five-minute parking written on the curb.

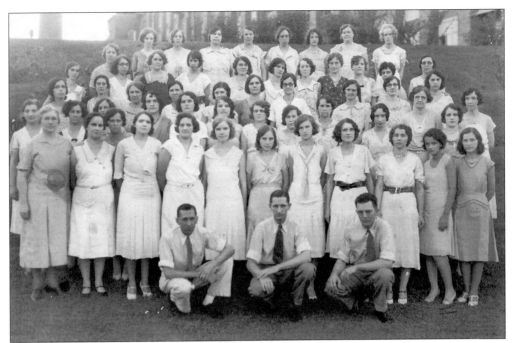

The employees of the Stehli Silk Mill are pictured in 1931. They were among the best-paid workers in the industry. Hester Hicks Idol, who was only 16, is seen second from right in the second row. The mill located in High Point around 1902 and remained in business until competition from synthetic materials forced its closure in 1935. Hester was Sue Foust's mother. (Courtesy Sue Foust.)

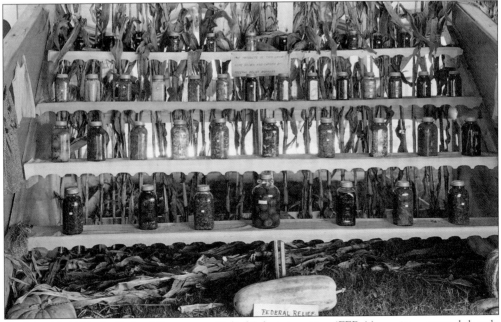

On May 22, 1933, the Federal Emergency Relief Administration (FERA) was inaugurated shortly after Franklin Delano Roosevelt took office. It tried to provide work for people on the relief roles. Programs for women, largely ignored before, included sewing, canning, nursing, and teaching. Here are the results of such classes.

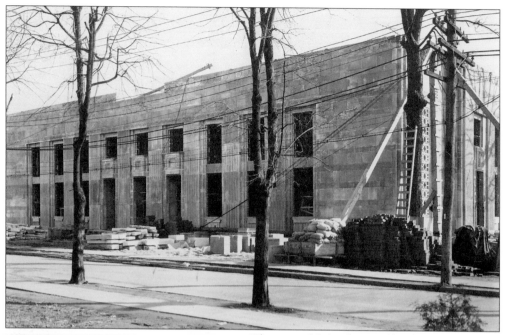

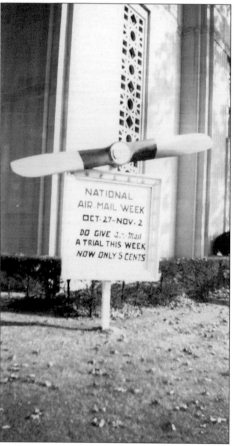

The second federal post office building, located at 100 East Green Drive, was a two-story structure designed by Workman, Everhart, and Voorhees of High Point and was constructed for $450,000. It was a Classical design with Art Deco details. The building was dedicated by the Honorable James A. Farley, postmaster general, on July 4, 1933. Stephen C. Clark was the postmaster for 20 years.

After the new post office was built, it advertised National Air Mail Week around 1934. The cost for a stamp was only 5¢. The propeller used to advertise the stamp was most likely one made by the Globe Furniture Company, which made wooden propellers for World War I.

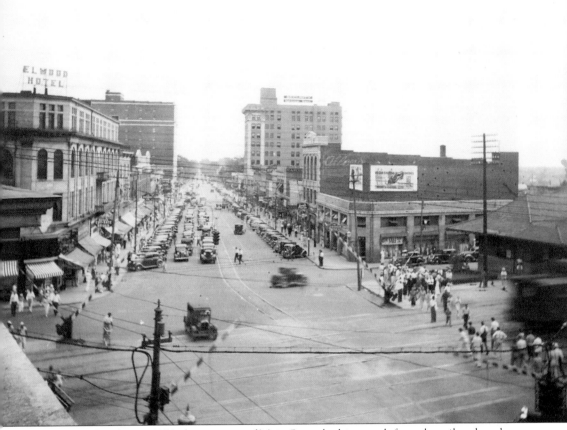

This photograph, taken in 1936, shows a view of Main Street looking south from the railroad tracks. A train is on the right having just crossed the intersection. Main Street was a busy thoroughfare with two lanes of traffic each way, trolley tracks, parking, and pedestrians. It is understandable how so many accidents occurred before the tracks were lowered. Most citizens of High Point know the story of the tracks being lowered. But few have seen just how busy Main Street was and why it was necessary to lower the tracks. This picture is believed to have been used to document the need to lower the tracks.

Located at 113 North Main Street was the Carolina Theater, originally the Broadway Theater, which was purchased and renamed in September 1933. It was again sold in June 1936 to the North Carolina Theaters, Inc. Betts Drug Store is to the left in the photograph. (Courtesy High Point Museum.)

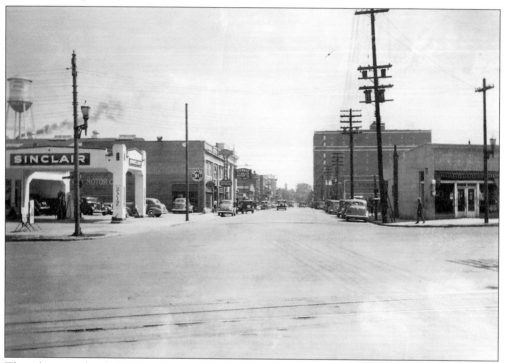

This photograph of 133 West Commerce Street shows a Sinclair Service Station. Just behind the station are three car-related businesses, Gate City Motor, J.C. Welch Motor Company, and Chevrolet. Note that the Southern Furniture Exposition Building is on the right with no expansions. It was built in 1921 with 249,000 square feet of space.

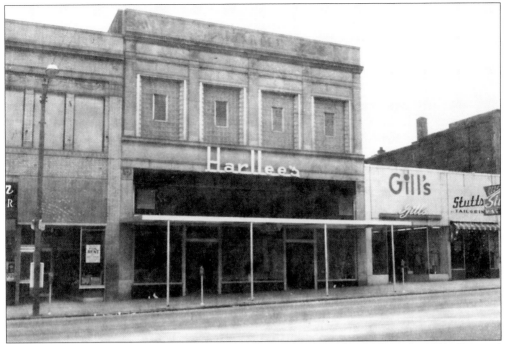

Downtown High Point was a thriving city full of businesses from the 1920s to the 1970s. Pictured is Harllee's, High Point's newest department store, which was opened in August 1934 on Main Street by F.E. Harllee Jr. Next door is Gill's Ladies Shop and Stutt's Tailoring Company. There were a variety of local merchants that provided diverse services long before the big "box stores" became popular. (Courtesy Joan S. Garner.)

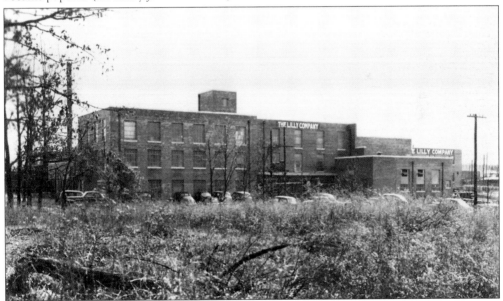

The Lilly Company opened a factory in High Point in 1935 to produce varnishes, lacquers, sealers, stains, and fillers. The company was located on English Street. In 2000, the company was purchased by Valspar, which still has a strong presence in High Point with multiple buildings on English Street.

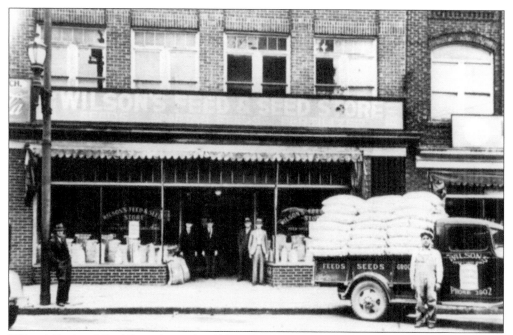

Wilson's Feed and Seed Store, located at 122 to 124 Wrenn Street, opened around 1937. It provided seed and fertilizer to many of the local farmers as well as feed for livestock. The storefront presence would move by 1940 to Russell Street where it was a wholesale operation. This became Hauser's Feed and Seed. (Courtesy High Point Museum.)

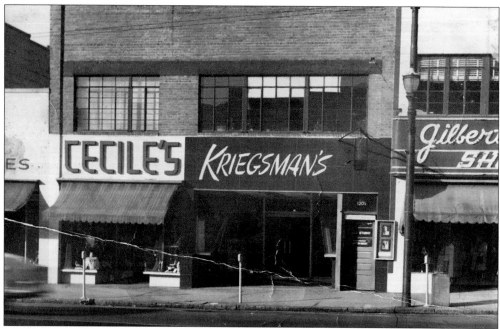

Cecile's Dress Shop was located at 122 South Main Street with Kriegsman's Furriers next door, followed by Gilbert Shoe Store at 120 South Main Street. The block on both sides of Main Street was owned by W.D. Simmons, who was involved in real estate. Most of the businesses were locally owned and operated. (Courtesy Joan S. Garner.)

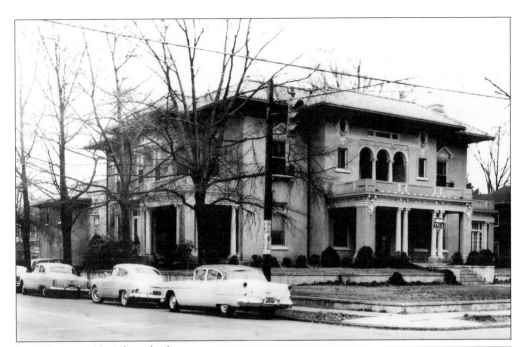

In 1918, James H. Adams built this home for his family on the outskirts of town at the corner of North Main Street and East Farriss Avenue. After his death, Mrs. Adams and her daughters gave the property to the Young Women's Christian Association for their use from 1939 to 1960. Today, the building is the J.H. Adams Inn, a boutique hotel with a restaurant. (Courtesy J.H. Adams Inn.)

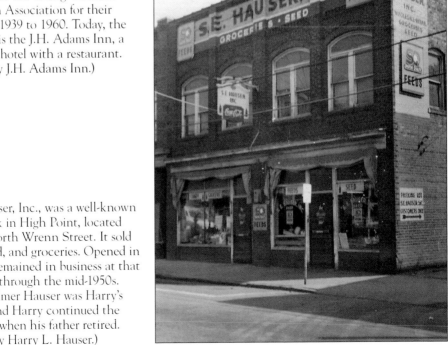

S.E. Hauser, Inc., was a well-known landmark in High Point, located at 118 North Wrenn Street. It sold feed, seed, and groceries. Opened in 1939, it remained in business at that location through the mid-1950s. Squire Elmer Hauser was Harry's father, and Harry continued the business when his father retired. (Courtesy Harry L. Hauser.)

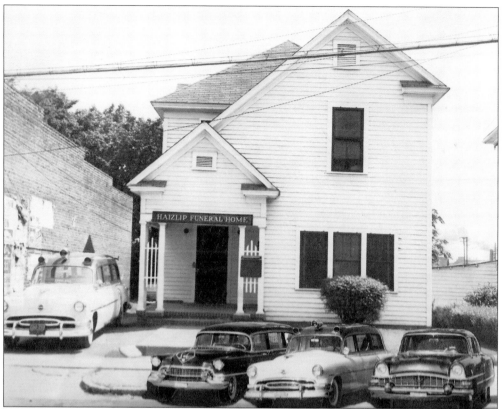

In 1940, Haizlip's third location was at 612 East Washington Street, seen here with four of their ambulances. Note the sign on the dashboard of the cars. At this time, funeral homes provided ambulances, which often doubled as hearses. The fourth business location at 206 Fourth Street was the city's first building constructed as a funeral home. It opened in 1961. (Courtesy Haizlip family.)

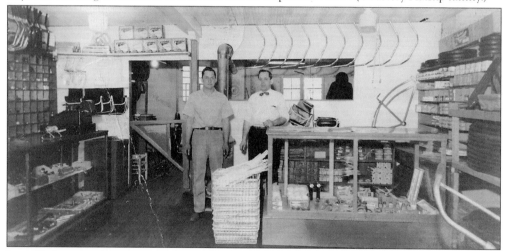

Jesse D. Jennings began his career in the automobile business working for George Lowe and Economy Auto Store. Around 1940, he started selling bicycles. George McDowell (left) and Jesse Jennings (right) are seen in the interior of Bicycle Sales and Service at 504 North Main Street. (Courtesy of Charles McDowell and Jesse D. Jennings family.)

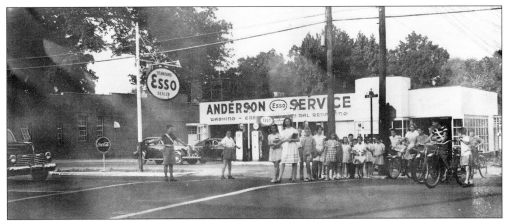

Anderson's Esso Service Station was located on North Main Street at the corner of Ray Street in 1947. A large number of children are being guided across Main Street on their way to Ray Street School. A gas station would remain at that site for another decade. Today, it is a parking lot.

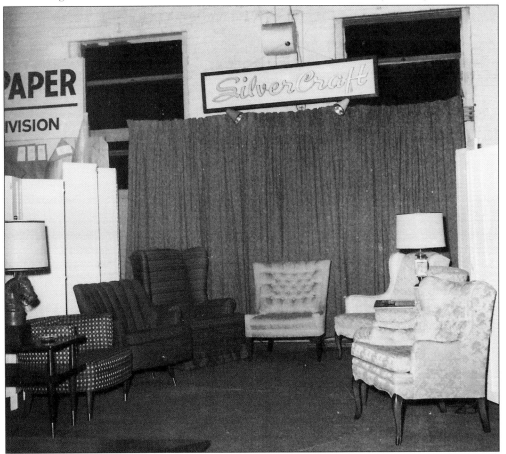

The Silver Craft Furniture Company, established in 1947 by Phillip Silver, made upholstered living room furniture. Darrell Pierce worked for this company from the late 1940s, joining his friend Norman Silver, son of Phillip Silver, after World War II. He retired as the company's general manager in 1984, when Norman Silver sold the company. (Courtesy Mark Pierce.)

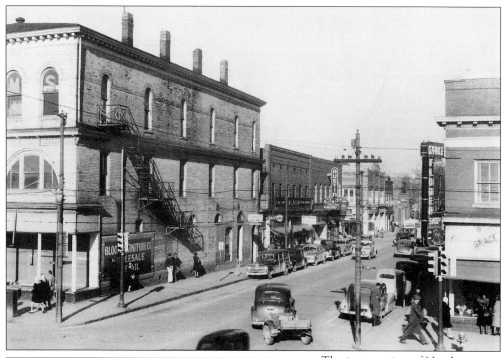

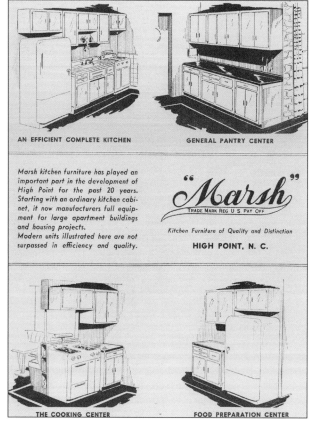

AN EFFICIENT COMPLETE KITCHEN **GENERAL PANTRY CENTER**

Marsh kitchen furniture has played an important part in the development of High Point for the past 20 years. Starting with an ordinary kitchen cabinet, it now manufacturers full equipment for large apartment buildings and housing projects.

Modern units illustrated here are not surpassed in efficiency and quality.

"Marsh"
TRADE MARK REG U S PAT OFF

Kitchen Furniture of Quality and Distinction

HIGH POINT, N. C.

THE COOKING CENTER **FOOD PREPARATION CENTER**

The intersection of North Main and East Washington Streets gives a quick glimpse of some stores active about 1949, including Grace Flower Shop and Bloom Furniture on North Main Street and Big Bear Grocery, Elite Bakery, and Austin's Furniture on the north side of Washington Street.

J.E. Marsh opened the Marsh Company in High Point in 1907. The company originally manufactured kitchen safes, kitchen tables, and hall racks. Over the years, they began to focus on making kitchen cabinets exclusively. This advertisement of their offerings in 1951 is for the complete kitchen.

In 1935, the Federal Communications Commission approved High Point as the new location for a broadcasting station, giving operating permission to J.A. Hart and Wayne M. Nelson. WMFR is High Point's oldest radio station, and its call letters were said to stand for "We Make Furniture Right." Seen here is Max Meeks, broadcaster, whose name is synonymous with the station. (Courtesy High Point Museum.)

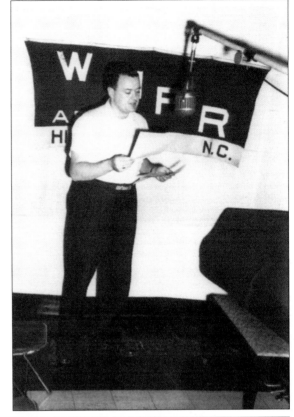

In order to keep the streets clean, the city water truck would fill up at a fire hydrant and then go up and down the streets spraying water. In the late 1950s, the children on Gatewood Avenue would rush outside when they saw the water truck was on their street so they could sit on the curb and be sprayed.

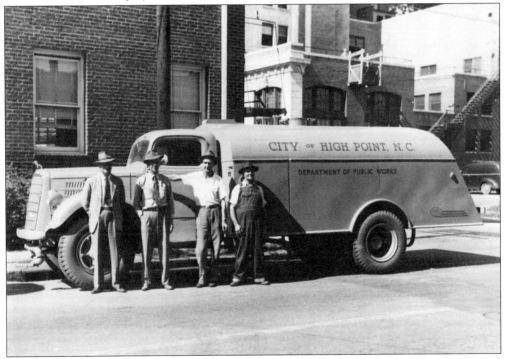

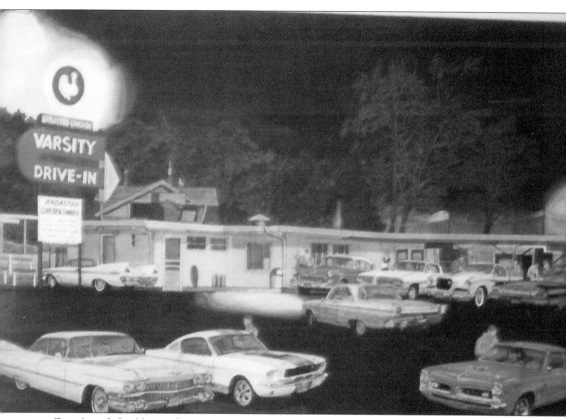

Zesto's and the Varsity Drive-In were two favorite eateries in High Point, both owned and run by Jim Walsh. Zesto's was located at 1230 North Main Street in 1950. Part of a national chain, Zesto's was a favorite place to get soft ice cream and floats, though it also served hot dogs and hamburgers. It closed in 1976. The Varsity Drive-In was popular with young adults who would come by after a movie or football game. It specialized in roasted chicken. It was located at 2410 North Main Street approximately where Gordy's is currently located. It opened in 1967 and closed 30 years later in 1997. Prints were made from original photographs for those who wished to remember their happy times there. (Courtesy Jim Walsh.)

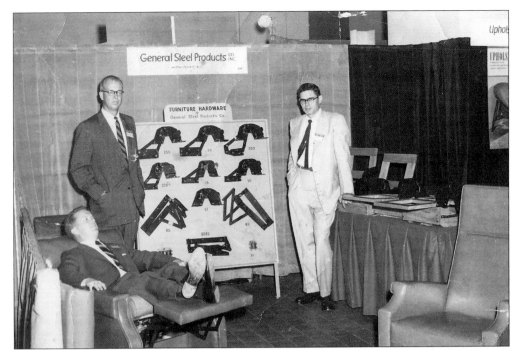

From left to right are Bill Bencini (in recliner), Jim Groome, and Frank Hoffman at the Chicago Furniture Market about 1957. General Steel Products manufactured furniture hardware, including a mechanism that was the forerunner of the recliner. Frank Hoffman is Steve Hoffman's father. Steve donated this photograph. (Courtesy of Steve and Mary Hoffman.)

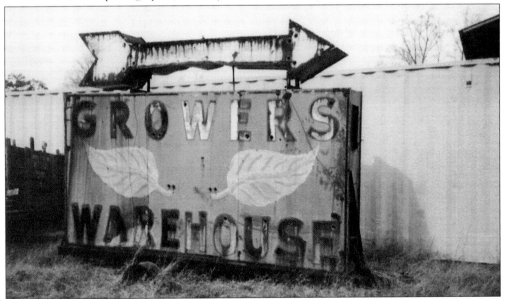

The retired Grower's Warehouse sign (decorated with tobacco leaves) is indicative of the demise of tobacco farming in this area. Not only are tobacco barns disappearing from the landscape, so too are the accompanying warehouses and processing plants. This sign on the Hedgecock Farm, photographed by the author in 2004, now sits in front of a trailer that has become the "new" tobacco barn. (Courtesy High Point Museum.)

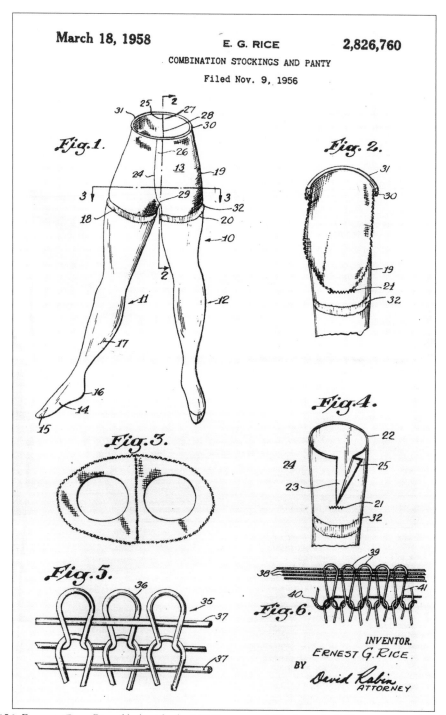

March 18, 1958 E. G. RICE 2,826,760
COMBINATION STOCKINGS AND PANTY
Filed Nov. 9, 1956

Fig.1.

Fig.2.

Fig.3.

Fig.4.

Fig.5.

Fig.6.

INVENTOR.
ERNEST G. RICE.
BY
David Rabin
ATTORNEY

In 1956, Earnest Gary Rice filed with the US Patent and Trademark Office to patent his design that would become known as "pantyhose." Granted the patent in March 1958, for the next two decades, his patent was contested. After Rice's death, the courts declared his patent valid, making him the designer of the first pantyhose. However, he received little compensation. Ted Rice, who contributed this photograph, was his son. (Courtesy Ted and Barbara Rice.)

Two

HOW WE PLAYED

High Point earned a reputation in the late 1890s as a vacation and health resort. Advertisements claimed benefits from "salubrious air, quiet and cheap living." A report claimed a mineral spring with "healing waters." In an 1892 publication, *Health Resorts of the South*, High Point is the only destination mentioned in North Carolina. The generous accommodations at local hotels, mild climate, and access via train helped to sell the area. Additionally, sportsmen from the North discovered plentiful quail and ducks in the area. By the turn of the 20th century, a number of estates were built for wealthy businessmen who would come south for hunting and recreation, usually arriving in their private railcars.

As the city grew as an industrial center over the next several decades, High Pointers turned some of their attention to the need for relaxation and fun. The Blair family donated acreage to the city on its southern border, and it became the first of numerous parks to be developed over the years. Federal money was used to create the next major park on the shores of the city's reservoir on the northern side of town. In June 1935, City Lake Park opened with tennis courts, land for picnics, and a swimming pool that was built to Amateur Athletic Union (AAU) specifications. It was considered the largest pool in the southeast when built and drew AAU championships as well as citizens throughout the area. Later that year, the city was called upon to approve funds for Washington Terrace Park. Three years later, a park for African Americans was completed. It drew African Americans from neighboring counties to High Point for recreation at the park.

High Point continues to provide recreational opportunities to its citizens with numerous parks, golf courses, and a Parks and Recreation Department that provides programs for all ages throughout the year, including a large swim meet and soccer tournament. Recently, bicycle, boat, and foot races have been added to the large offering of activities.

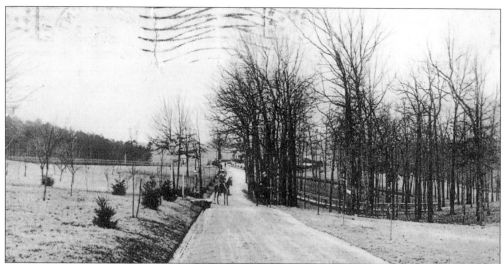

This postcard shows the long lane into W. Gould Brokaw's lodge located south of High Point. In 1903, Brokaw of New York built a 20,000-acre sporting retreat known as Fairview Lodge. High Point was a favorite destination for hunters. Wealthy men of the North would travel by train to High Point to shoot quail. (Courtesy Michael L. Brown.)

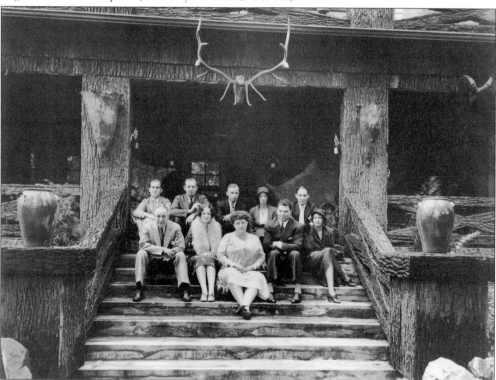

Harry Raymond (first row, left) founded his veneer company in 1914 in Indiana but relocated his business in 1921 to be close to his furniture customers. Like many wealthy men of the day, he built the FritzHarry Lodge near Sedgefield in 1926 as a private hunting retreat, naming it for his granddaughter "Fritzie" and himself. In later years, it became the Embassy Club. (Courtesy High Point Museum.)

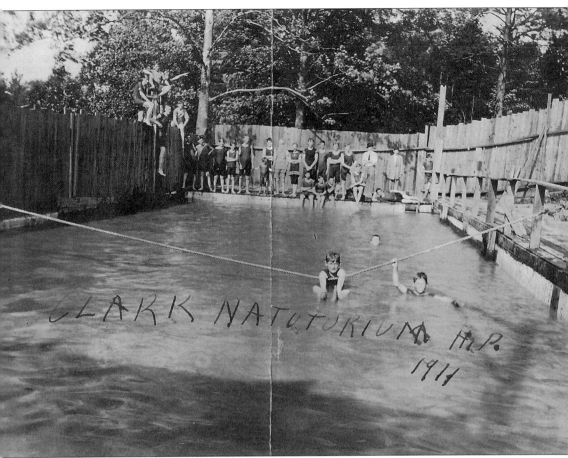

Clark's Natatorium was the first public pool in High Point, built around 1911 on Centennial Avenue. A fee was charged to swim, so it was a moneymaking venture for D.L. Clark. The Commercial Club had a private pool at this time. Here, children are enjoying a swim during a lazy day of summer.

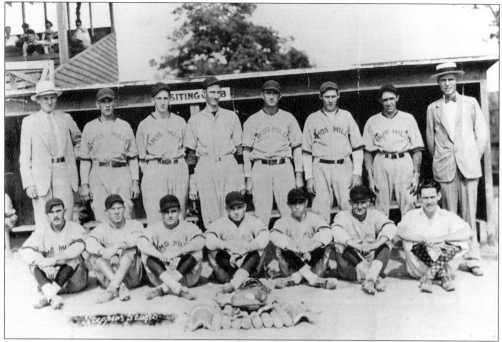

Amos Hosiery Mills, founded in 1916 by brothers R.T. and Charles Amos, manufactured socks and was once one of the largest mills in the city. Like many companies during the 1930s, the mill sported a baseball team that competed against other companies (above). There were three leagues in High Point: amateur, commercial, and industrial. Competition for players between the companies was very strong. Companies that hosted teams included Adams-Millis, Carolina Container (below), Snow Lumber Company, Harris-Covington, Tomlinson, Marsh, Globe Parlor, and Roberson Bakery, among others. The leagues were under the supervision of the YMCA. Below is the Carolina Container team in 1932–1933. (Courtesy High Point Museum.)

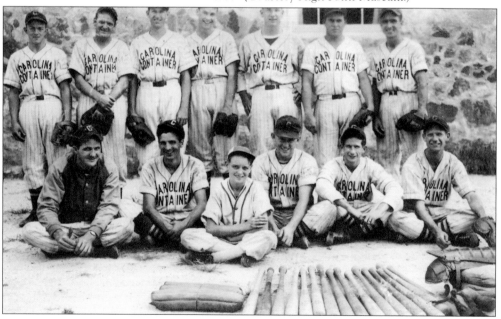

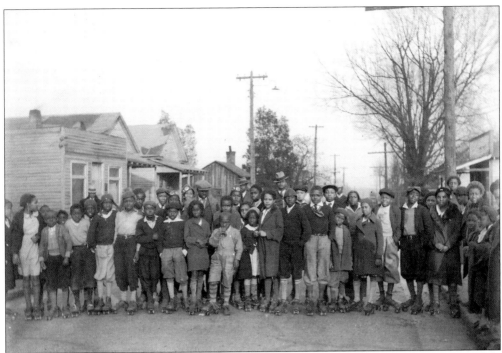

Low wages and widespread unemployment brought on by the Depression left families looking for inexpensive entertainment. Popular activities included cards, jigsaw puzzles, and board games like Monopoly. Hundreds of children around the city enjoyed roller-skating from the 1930s to the 1950s. The cost for a pair of skates in the 1930s was between $1 and $4. Kids would simply clamp the skates onto their shoes, tighten them with a key, and away they went. Whole neighborhoods enjoyed this activity. Above, these African American children are from the Leonard Street neighborhood. Most children spent the day outside playing with other children in the neighborhood.

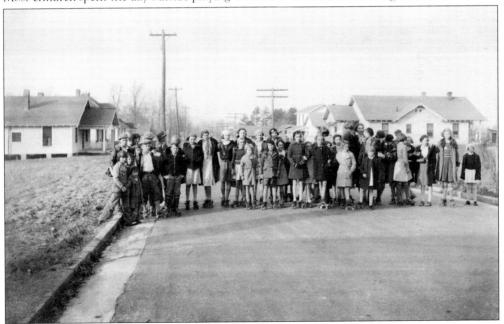

Samuel Hunt owned property on South Main Street and shared his home with his daughter Abigail and her husband, Solomon Blair. He ran the Blair Dairy. The dairy was active until his eight children decided to donate the land to the City of High Point to create the town's first park, Blair Park. (Courtesy Springfield Memorial Association.)

The need for parks in High Point had been expressed in the 1910s and 1920s but was put on hold during the Depression. Plans were resurrected when the Blair family gave 73 acres of land along Richland Creek in the southern section of the city. The new park was dedicated in 1931 and was the "initial unit of the city's proposed system of parks," according to the *High Point Enterprise*.

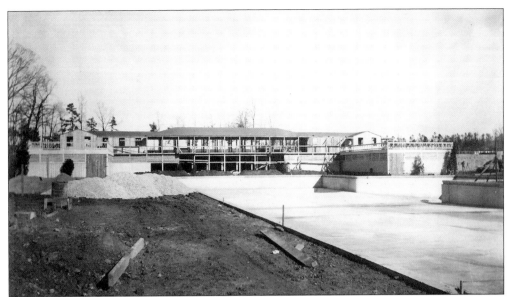

The City Lake Park pool and bathhouse were under construction in December 1934 as part of a large complex (above). When the pool was built, it was the largest in the Southeast at 165 feet wide and 270 feet long. The park was paid for with money from the Works Progress Administration (WPA). The park opened on Friday, June 28, 1935, and was deemed the "finest of its kind in the southeast," according to the *High Point Enterprise*. Gala opening activities concluded with a community picnic. Entrance to the pool was 25¢ per adult and 15¢ per child. With that, customers were given a towel, soap, and an envelope in which to check valuables. Even bathing suits could be rented. (Courtesy Parks and Recreation Department.)

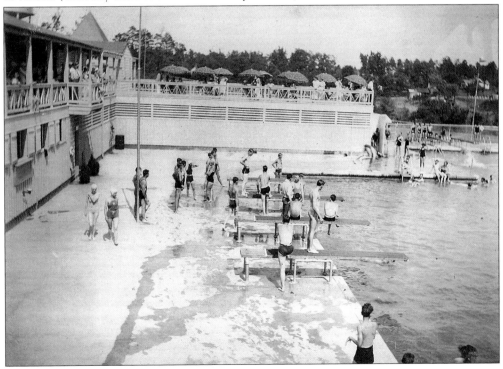

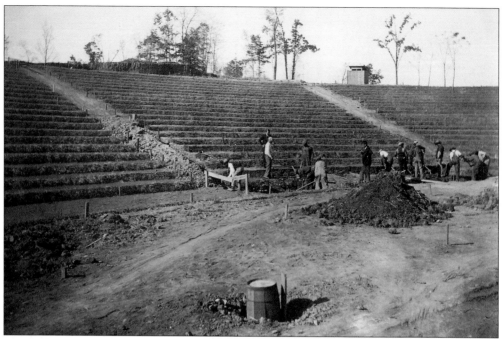

This view of City Lake Park shows the amphitheater under construction in 1934. Dirt from the pool was carted east of the swimming area by hand to create an impressive amphitheater. It seated 2,000 people and could accommodate a cast of 100 on its stage.

Construction of Washington Terrace Park was approved on November 12, 1935, when city council voted for several WPA projects for the town. Up until that point, there had not been a park for African Americans. The park included a swimming pool, patio areas, two baseball diamonds, a baby pool, swing sets, and jungle gyms. It opened in 1938 at a cost of over $100,000.

W.G. Shipman is seen here with his daughter Elizabeth about 1910. He started the Shipman Organ Company in 1905. In 1911, the company erected a new 50,000-square-foot plant. The plant burned in 1918. Organs were a primary form of entertainment in homes, long before the invention of radios and televisions. The organs were sold throughout the South. (Courtesy Richard F. Wood.)

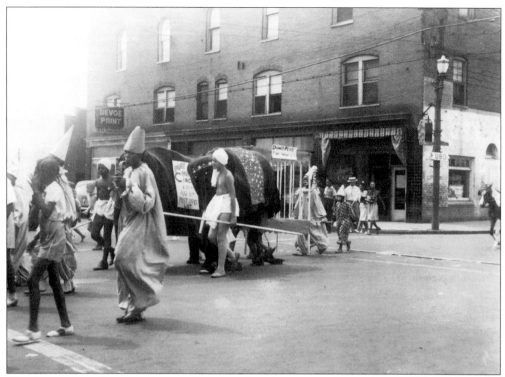

The Annual City Playground Circus Parade included a variety of participants. Above, Lee Gilmer and James Cobb were dressed in "native garb" as elephant boys. In the photograph below, people are dressed as giraffes and elephants. Stern warnings against feeding the "animals" were posted. Early forms of transportation included the horse and buggy seen below as well as a covered wagon. Phil and Dave Phillips, sons of Mayor Earl Phillips, are driving the wagon. Everyone enjoyed the circus and parade. Note the sign for the Sanitary Café in the background.

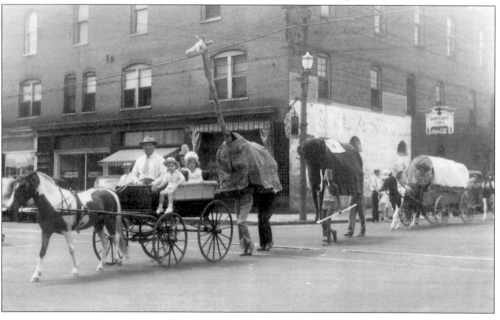

On August 11, 1945, the citizens of High Point flocked to the post office lot on South Main Street to be part of the Annual City Playground Circus. As the parade wound around the city, spectators were delighted with the "animals." Among the spectators was city manager Roy S. Braden.

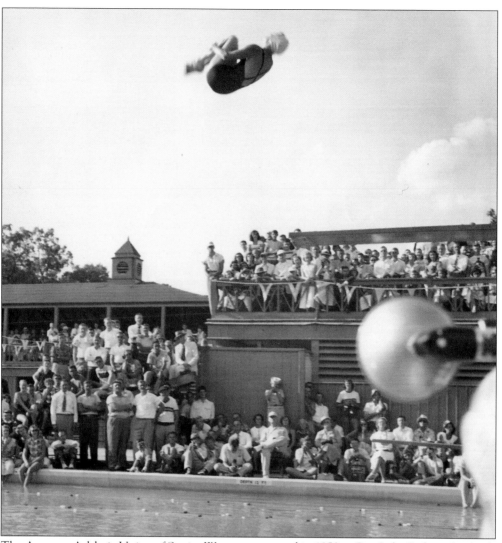

The Amateur Athletic Union of Senior Women competed in 1950 at City Lake Park pool in both swimming and diving events. Pictured here is the three-meter competition. Hundreds attended this exciting event. Swimmers from Oregon, Chicago, Atlantic City, and West Palm Beach participated. (Courtesy Parks and Recreation Department.)

Windley Dunbar (right) purchased this bike from Bicycle Toy and Hobby Sales in 1951 with money he earned by mowing the lawn and selling vegetables from the family garden. He is talking to the store owner, Jesse D. Jennings, who opened his first store on Main Street. (Courtesy of Charles McDowell and family of Jesse D. Jennings.)

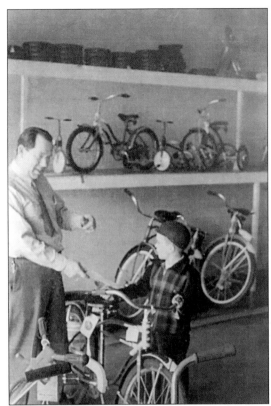

On July 5, 1952, after two days of trials, Larry Peterson of Archdale, sponsored by Mickey Body Company, was the winner of the Second Annual Derby Day in High Point. He competed in 1951 but placed second. That year, the winner won a free trip to Akron, Ohio, to compete in the National Soap Box Derby. Approximately 40 boys competed in building motorless midget racers. (Courtesy High Point Museum.)

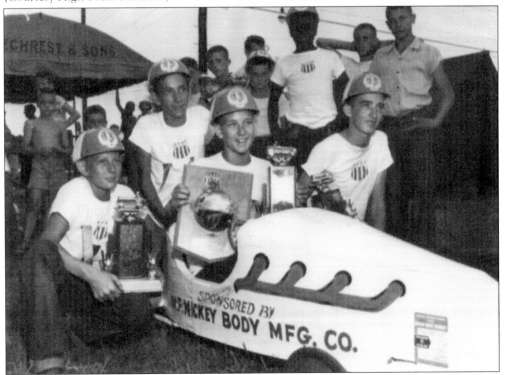

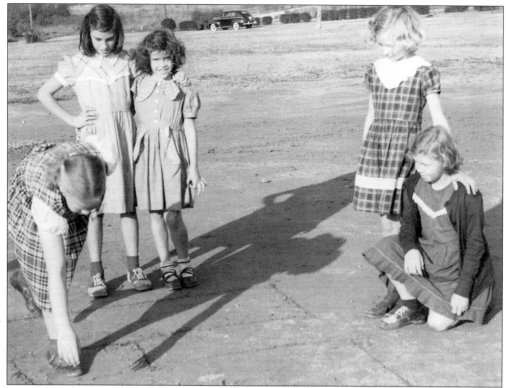

Hopscotch was a favorite activity for younger children. Here, several young ladies are playing at Brentwood Play Ground in 1952. It was customary at the time for young girls to wear dresses, even while playing. Hopscotch was first recorded as a game in the late 17th century. (Courtesy Parks and Recreation Department.)

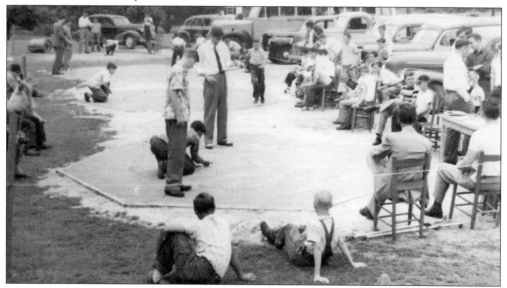

Marbles, played the world over and thought to have originated in Pakistan, is also mentioned in ancient Roman literature. The North Carolina Recreation Society held a marble tournament at Blair Park in 1953. Children, all boys, from around the area participated in this fun activity.

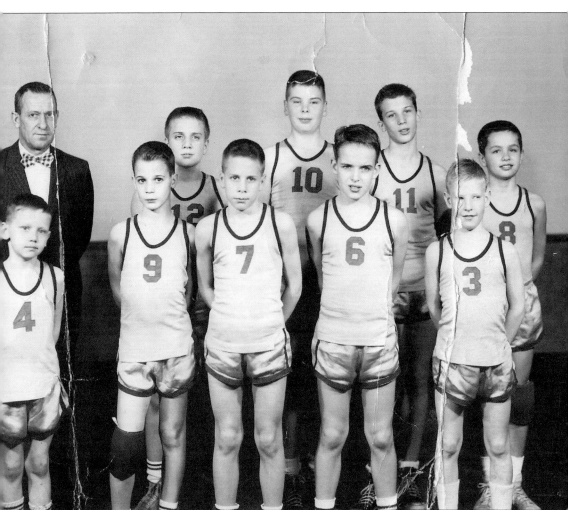

"Chigger" Moffitt is pictured with the 10-year-old basketball team from the Young Men's Christian Association in 1958. From left to right are (first row) Jamie Ragan, Tim Elliott, unidentified, Mike Carr, and George Holbrook; (second row) Moffitt, Bobby Adams, Mac Younts, Tony Elliott, and Steve Hoffman. The YMCA was located at 401 South Main Street. (Courtesy Steve and Mary Hoffman.)

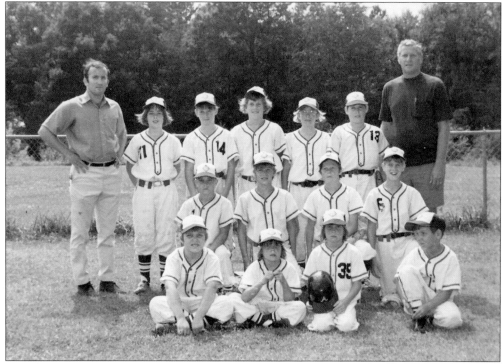

The Varsity Drive-In Little League was coached by, from left to right, Larry Cecil and Earl Campbell. Also pictured are Patrick Campbell (second row, fourth from left) and Chris Whitley (third row, second from right). Little League has been a popular pastime for decades. Bobbi Campbell was the sister of Larry Cecil, wife of Earl Campbell, and mother of Patrick. (Courtesy Bobbi Campbell.)

The High Point Parks and Recreation Department offered something for everyone. This photograph shows the Civic Clubs Sports Festival that was held in City Lake Park during the 1950s. One of the activities was casting fishing lines. Presumably, the length of cast was measured to determine the winner. Note how formally people are dressed.

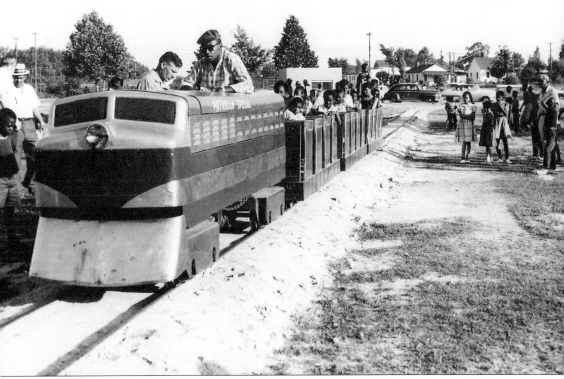

In 1960, the Patrician Club donated a miniature train, the *Patrician Special*, to Washington Terrace Park. Club members were the first to ride the three-car train around the 1,300-foot track. Thirty-six children could ride at one time for a fare of 10¢ each for two laps around the track. The train reached a top speed of seven miles per hour.

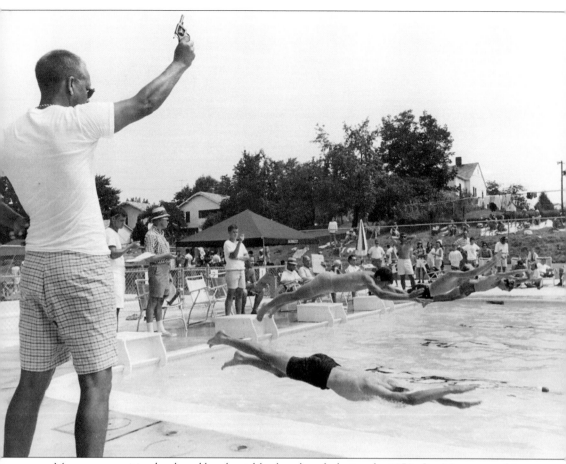

Many communities developed local neighborhood pools during the 1950s. Jim Morgan, working as a lifeguard, helped to arrange the first community swim meet involving the various neighborhood pools in the summer of 1965. Dee Haddock was the starter for the race. (Courtesy Jim Morgan.)

Three

How We Learned

The Quakers strongly believed in education and took a lead role in providing it for their families as well as others. After the Civil War, the Baltimore Association of Friends recognized the devastation of many of North Carolina's farms. As this area had good leadership and was seen as a "Capital of Quakerism" in the state, Northern Friends planned to help the area, including rebuilding schools and meetinghouses, training teachers, and helping farmers reclaim the soil. They began a project called the Model Farm, which would teach farmers innovative farming methods. A local Quaker, Solomon Blair, opened a two-room school for African Americans in 1867, as laws prohibited the education of white and blacks together. In 1880, Quakers from New York established a school in Asheboro, which merged with the Blair School in 1891.

High Point had some subscription schools and private academies in the late 1880s for white children but no tax-supported public schools in the city. In 1893, the New York Society of Friends began the High Point Normal and Industrial Institute, an outgrowth of the Blair School, and relocated the campus to Washington Street. It provided instruction in trades as well as academics to African Americans. The Society of Friends turned over the administration of the school in 1897 to the City of High Point. This led to High Point committing to a graded school system with the purchase of a building owned by J. Elwood Cox that same year. Thus a formal education system, though segregated, was started. In the next two decades, many new schools were constructed, as industry brought more people to the town.

High Point would also become the location for a four-year liberal arts college when the Methodist Protestant Church opened High Point College in 1924. Many years later, in 1991, it would become High Point University and offer post-graduate degrees. In the last five years, it has seen tremendous growth under the supervision of Nido Qubein, president of the school. Laurel University and South University are other schools of higher education. High Point is home to many private schools as well.

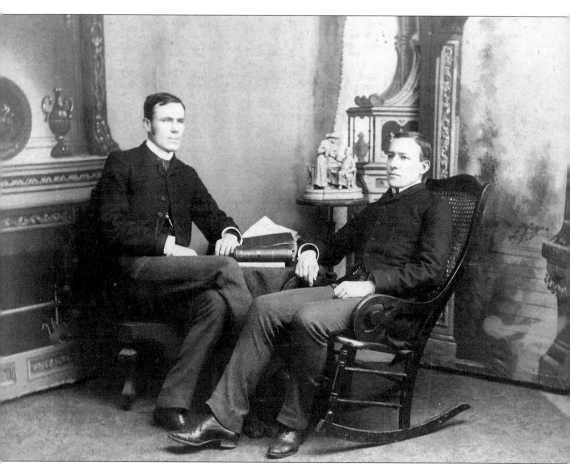

John Jay and William A. Blair are pictured here probably at Guilford College, where they attended school. William was principal of the first free school in High Point. In 1885, he purchased Lynch's Select School for Boys. John Jay later took over the leadership of the school. At different times, William was superintendent of schools in Winston-Salem and High Point. (Courtesy Springfield Memorial Association.)

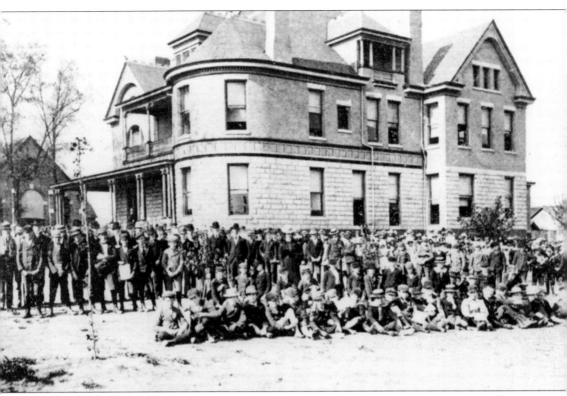

High Point Graded School building was opened on September 20, 1897. The school was originally built by J. Elwood Cox as his private residence for $15,000. He sold it to the city for $6,500. This was the first public school in High Point and the beginning of the school system. Twelve school commissioners were appointed to oversee the school system.

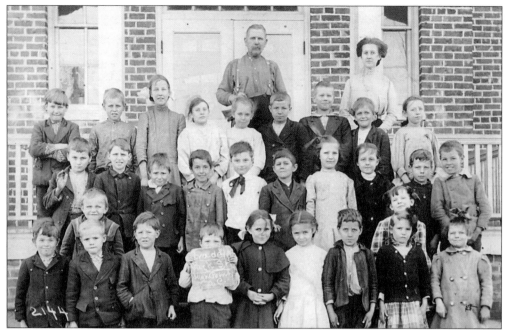

Second graders stand for their picture in front of the Park Street School, which was built in 1909. It was the third public school in High Point and was located on East Russell Street at the corner of Park Avenue. The teacher is only identified as "Anne." It is not known who the gentleman was, perhaps the janitor.

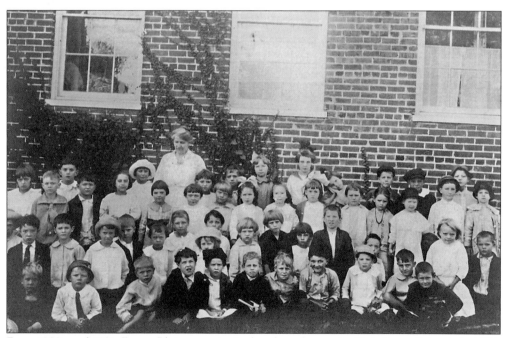

From 1909 until 1921, Emma Blair was principal and teacher at the Park Street School. In 1920, a new building was constructed on an adjacent lot and was named the Emma Blair School. Blair is pictured here with her students at the Park Street School.

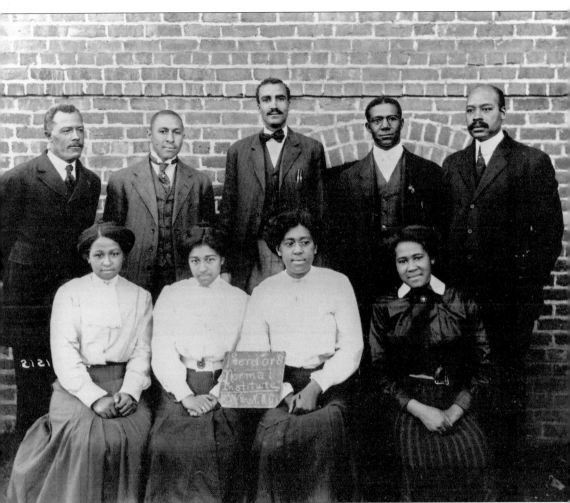

The 1912 seniors at Normal Institute are pictured with A.J. Griffin (second row, far left) and E.E. Curtright (second row, far right). Griffin was principal of the school from 1897 to 1923. Under his leadership, the school grew substantially, adding Congdon Hall to house female students and a building (constructed by the students) for science and industrial arts.

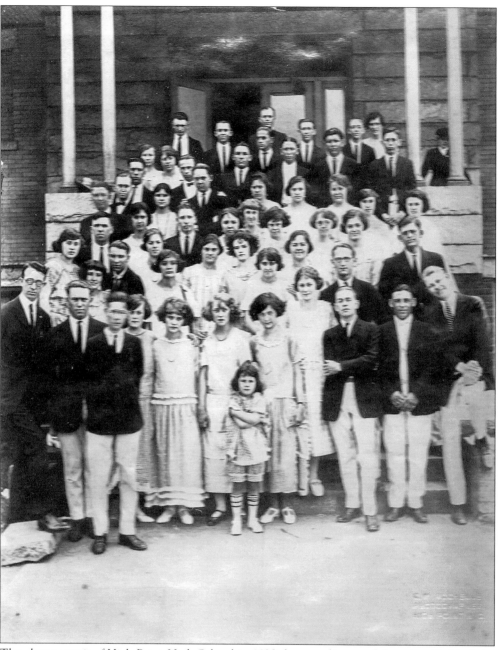

The class portrait of High Point High School in 1923 shows a glimpse of the school behind the group. It was opened in 1897 as the first graded school. May Ferree Frazier is pictured third row, second from right. She is the mother of the photograph contributor, Rudy Frazier. (Courtesy Rudy Frazier.)

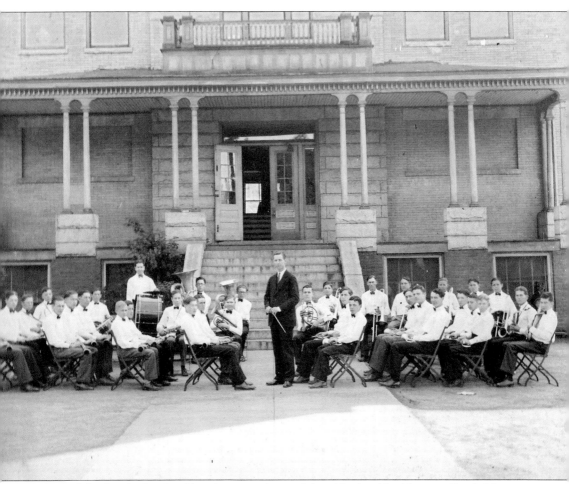

Members of the first high school band pose in front of the old school building on South Main Street. This photograph may have been taken in 1926, shortly before the new school opened. The young man seated second from the right, playing the saxophone was Jim McLeod, uncle of Bobbi Campbell. (Courtesy Bobbi Campbell.)

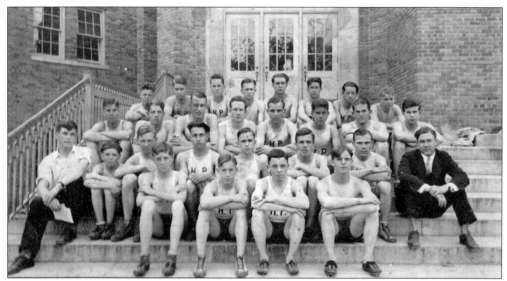

The High Point High School track team, pictured about 1928, was one of the first at the newly constructed high school. Harry Williamson (first row, far left) attended the 1936 Olympics held in Berlin. E.W. Freeze Jr., manager (second row, far left); Charles E. Spencer, coach (second row, far right); and Obed Hancock, captain (third row, second from left) are also seen here. (Courtesy Bobbi Campbell.)

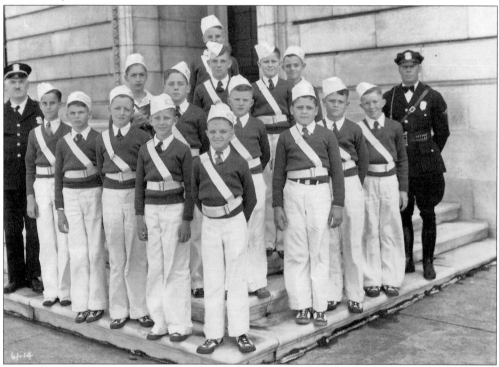

Many schools had patrols that helped guide students across traffic. The 1932 minutes of the Board of School Commissioners mention that Sergeant Samuels asked for $75 to $100 to purchase jackets and hats. Here is the 1933 Fifth Grade Patrol Boys. Steven J. Clark is in the second row on the left, and Sergeant Pike is on the right.

The new High Point Junior High School (now Ferndale Middle School) opened following the Christmas vacation of 1931. This building was a smaller version of the Gothic-style High Point Senior High School that opened in 1927. The students gathered their books at noon on December 18, 1931, and walked to the new junior high, which became their school in January 1932.

High Point College was the result of a Methodist Protestant campaign to provide for proper education for members of the church. The Jamestown Female Academy was considered a precursor of High Point College. In December 1923, the academic building, Robert's Hall, was completed. In a ceremony on May 14, 1924, the Masons of High Point led the way as cornerstones were laid for two dormitories. (Courtesy High Point University.)

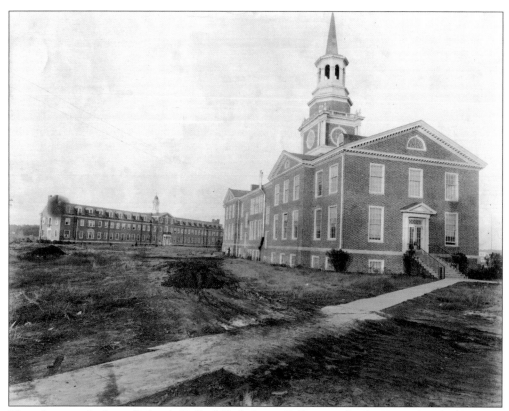

This photograph shows Robert's Hall of High Point College in the foreground with the newly constructed dormitory in the background, not quite finished for the opening of the school in 1924. Unfortunately it rained opening day, and for three weeks thereafter, leaving the campus a sea of mud. Students walked on planks to get to their classrooms. (Courtesy High Point University.)

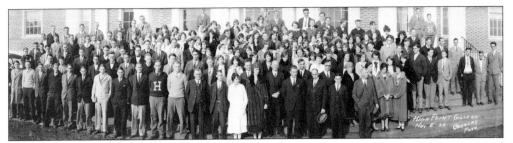

On November 5, 1925, this group of students and teachers were photographed as the first to attend High Point College. The first degrees were awarded on May 19, 1927. Twelve bachelors of art and one bachelor of music were awarded. The first students to receive degrees had transferred to High Point as sophomores from other schools. (Courtesy High Point University.)

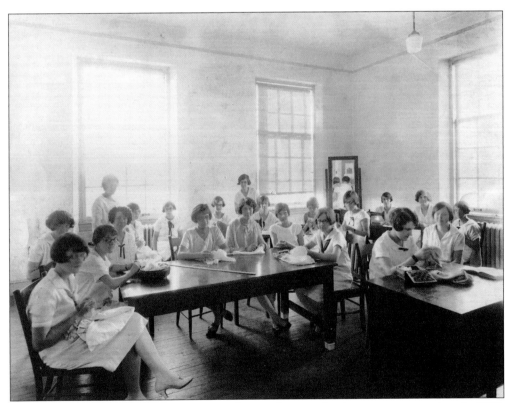

These women are practicing sewing by hand or machine in this home economics class. In 1928, a new bachelor of science degree was introduced at High Point College and awarded to those who completed coursework in biology, chemistry, music, or home economics. (Courtesy High Point University.)

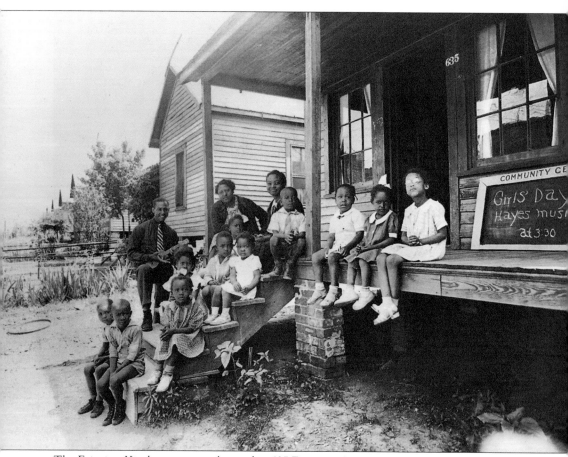

The Fairview Kindergarten was located at 635 Fairview Avenue in 1937. It was in business only a year or two. As one can see from the chalkboard sign, other activities were conducted here. On this day, it is listed as a community center with girl's day for the Hayes Music Club.

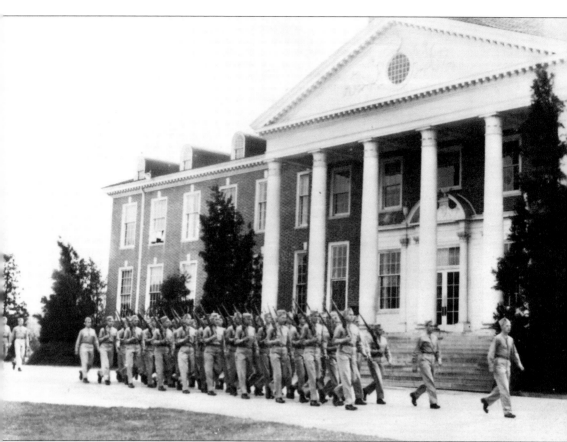

High Point College hosted an Army Air Corps detachment during World War II. Hundreds of cadets attended courses and drilled on campus. While on campus, the group lived in McCulloch Hall. After the war, Millikan Hall on the East Campus at Five Points housed married veterans. (Courtesy High Point University.)

Children are lined up for a May Day celebration of dancing around the maypole. They attended Kirkman's Kindergarten on Otteray Avenue. Note all the girls are wearing the same dress. Mothers were asked to make their daughter's dresses out of crepe paper. The young girl fourth from the right is Anne Welborn. (Courtesy Anne Welborn Andrews.)

Four young ladies stand in front of the "Little Red Schoolhouse" in 1945. The single-classroom building was designed in 1930 by Louis Voorhees, local architect, to be used for first-grade students to ease the overcrowding at Ray Street Elementary. Voorhees's wife, Elizabeth, was the first-grade teacher. The building was later moved to East Lexington Avenue and is now owned by the High Point Museum. (Courtesy Anne Welborn Andrews.)

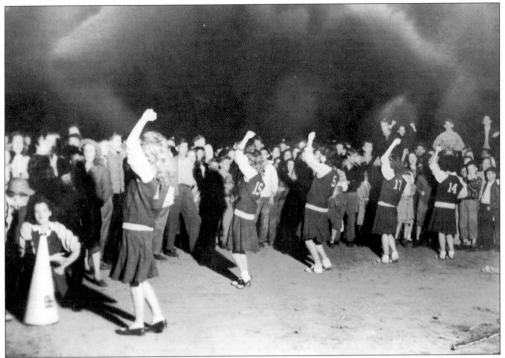

The 1946 class of High Point High School is enjoying being cheered on by their cheerleaders. The head cheerleader, Joanne Sechrest, is seen sitting on the left side of the photograph. Other cheerleaders include, from left to right, Betsy Hardin, Dot Collins, Margaret Washburn, Joyce Linthicum, and Betty Darby. Their outfits are more modest than today's cheerleaders. (Courtesy Joan S. Garner.)

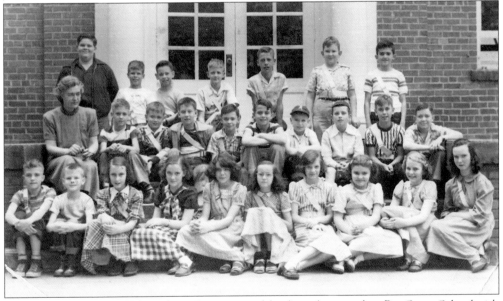

The 1949–1950 class of fifth-grade students is seated for their photograph at Ray Street School with their teacher, Rosalind Ruscoe. Ray Street School was built in 1923. On the reverse of the photograph are 22 signatures of many of the students in the class. (Courtesy Anne Welborn Andrews.)

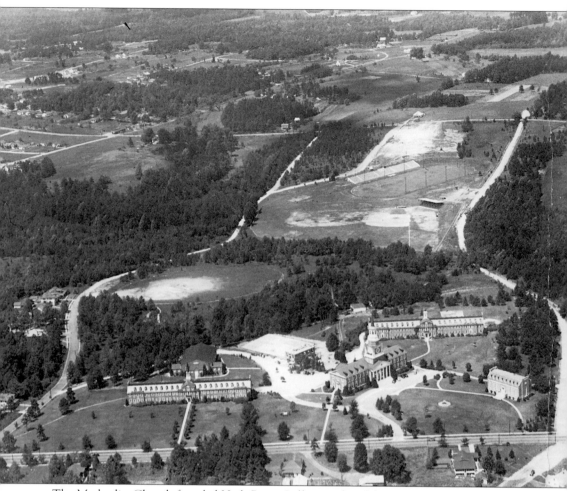

The Methodist Church founded High Point College with aid from the City of High Point. This aerial view of High Point College campus predates the construction of the College Village Shopping Center. The campus was situated south of Lexington Avenue between East and West College Streets. The Albion Millis Stadium is at about the middle right of the c. 1950s photograph.

The second-grade class of Oak Hill Elementary School in 1954 had their photograph taken with their teacher Lucille Ingram. Boys and girls were well dressed for the occasion. Linda Russell Williard is pictured in the second row, second from right. Oak Hill School was on Wrightenberry Avenue. (Courtesy Linda R. Williard.)

William Penn High School, a school for African Americans, was known for its athletics and marching band. The band was begun by the Parent Teacher Association (PTA) with the purchase of six clarinets and a set of drums in the 1930s. J.Y. Bell was the director of the band in the 1960s. The school closed in 1968 when the local schools were integrated. (Courtesy High Point Museum.)

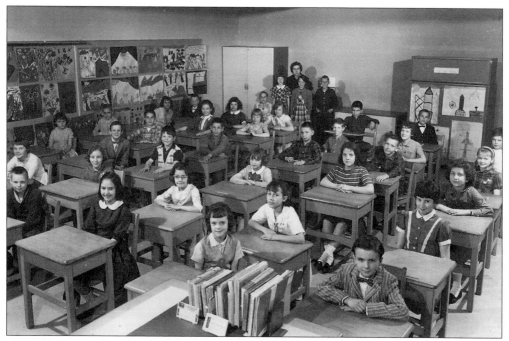

Emma Blair School students sit at their desks for their class photograph. Built in 1920 at a time of rapid expansion in High Point for $130,000, it was named for Emma Blair, who taught in the system for many years. She was principal of the school until she retired in 1942 at the age of 78. The school closed in 1971.

In 1947, the first driver-training program in the state began at High Point Senior (Central) High School. The instructor was Sgt. J. Frank Shields. The Rotary Club, the City of High Point, and the PTA made it possible. Sergeant Shields was a city police officer before becoming the driving instructor.

Four

HOW WE WORSHIPPED

Quakers, or the Society of Friends, were among the first people of European background to settle in this area. It is their religion that gave strong definition to High Point and its development. They came from Massachusetts and Pennsylvania in the 1750s and established meetings, as their churches and congregations are called. The first two meetings were established at Deep River and Springfield, to the north and south of what would a century later become the town of High Point. The Quakers settled the land and were farmers and craftsmen. They brought with them a strong belief in education, not only for men, but for women and people of color as well. They did not believe in war or the enslavement of others and strived to live an exemplary life. Their influence in High Point was particularly felt in education and the recovery from the Civil War.

As a southern city in the "Bible Belt," it is not surprising to learn that High Point is also the home of many other religions, including Baptists, Methodists, Presbyterians, Lutherans, Episcopalians, Mormons, Catholics, and Jews. New religions are still coming into the area as new populations relocate here.

Rev. J.C. Dinwiddie was pastor of the First Presbyterian Church from July 1891 to December 1893. In September 1892, he organized a mission church in Jamestown and preached there the third Sunday afternoon in each month. Another mission was established in the Macedonia area and led by Elder E.A. Snow.

Clara Cox was the daughter of J. Elwood Cox and granddaughter of William H. Snow. She was pastor of Springfield Friends Meeting for 21 years, from 1918 to 1940, and was active in civic organizations that served women, children, and those in need. The Clara Cox housing project was named in her honor in 1942. (Courtesy Springfield Memorial Association.)

This group of ladies, pictured in 1926, was known as the Friendly Twelve from the Main Street Methodist Church. From left to right are (first row) Marie Wright, Viva Wilson (mother-in-law of photograph donor), Violet Connor, Mary Ellis, Martha Jester, and Lillie Plummer; (second row) Eva Spencer, Pearl Connor, Ethel Russell, Fanny Puddy, Nina Rogers, and Pauline Pitts. (Courtesy Dell Wilson.)

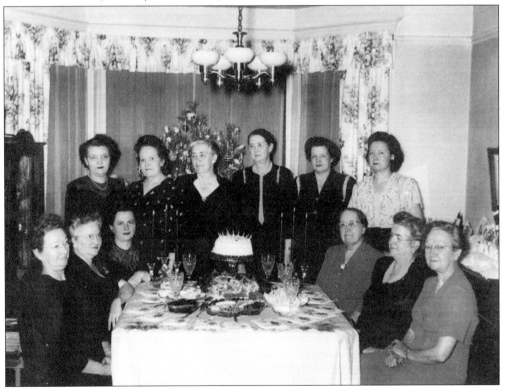

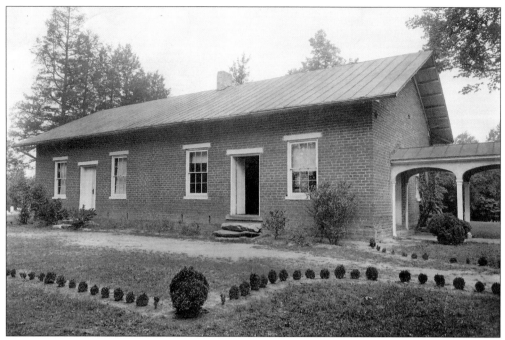

The third Springfield Friends Meeting House was built in 1857 with handmade bricks. It was used until 1926 or 1927, when the new meetinghouse was constructed. John Jay Blair suggested the old meetinghouse be made into a museum, and he went throughout the Quaker community gathering artifacts. Today, it serves the community as the Museum of Old Domestic Life. (Courtesy Springfield Memorial Association.)

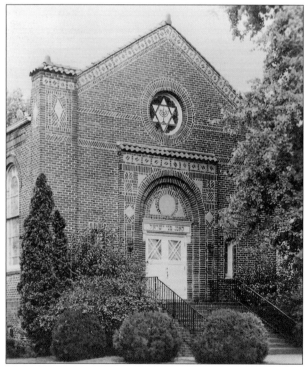

The first Jewish families moved to High Point in 1888. They were Louis and Henry Harris. On September 7, 1927, when the B'nai Israel Temple was completed and dedicated for worship at the corner of Hamilton and Ray Streets, there were 27 families. Later, an educational facility was built adjacent to this beautiful synagogue, which survives as the Culler Senior Center. (Courtesy B'nai Israel Congregation.)

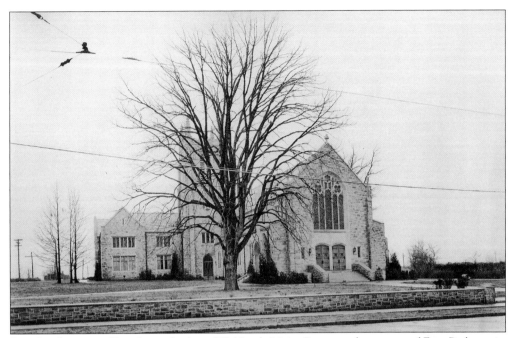

First Presbyterian Church was built at 918 North Main Street at the corner of East Parkway in 1928. It was the third sanctuary for the church. The building was designed by Hobart Upjohn of New York City, assisted by Greensboro architect Harry Barton. The elegantly detailed, Gothic-style stone church is one of the most beautiful in the city.

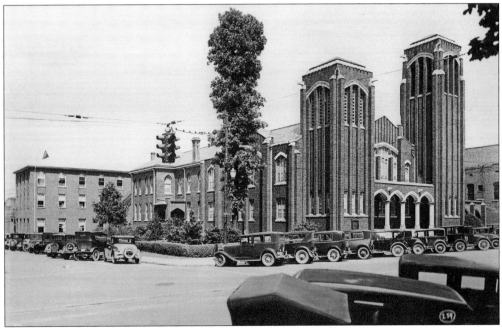

Wesley Memorial Methodist Church, located at 300 North Main Street, was completed in 1914. The third building to house the congregation (the first two having been on Washington Street) could seat 500 with the balcony holding an additional 200. A Sunday school building was added in 1926. In 1960, the church relocated to its present campus at 1225 Chestnut Drive.

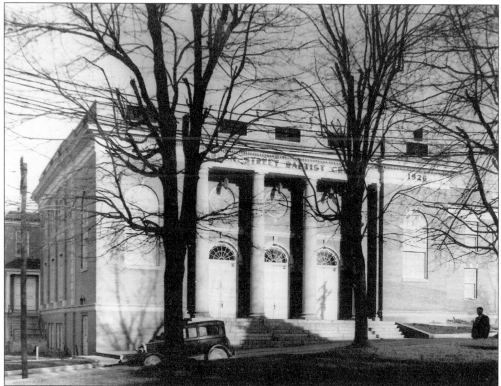

Green Street Baptist Church was a two-story, brick, Neoclassical Revival–style church built in 1926 on the southeast corner of South Centennial Street and East Green Drive. The congregation organized in 1897 as a Southern Baptist mission and changed to its current name in 1900. Their current campus is on Phillips Avenue where the historic Hoggatt House once stood.

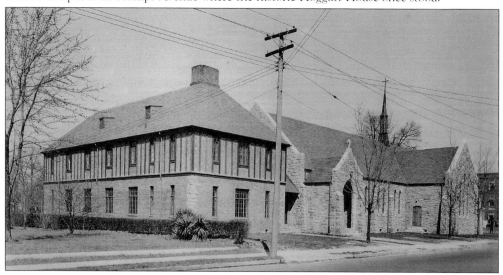

St. Mary's Episcopal Church, with predecessors of different names, started in High Point in 1882. A new stone church was under construction in 1927 at the corner of North Main Street and West Farriss Avenue. The architects of the Gothic-style church were Herbert Hunter, Louis Voorhees, and Eccles Everhart.

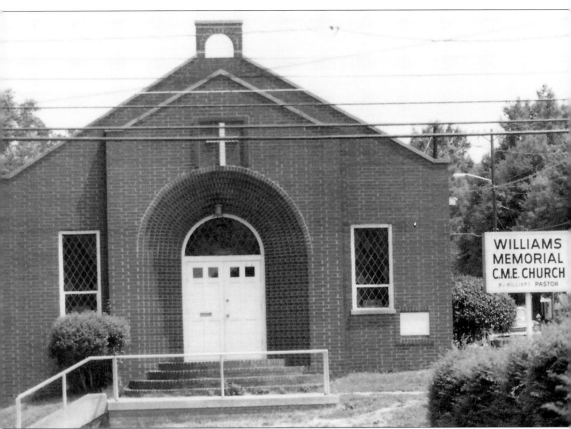

Williams Memorial Christian Methodist Episcopal Church began in 1926 at the home of Willie and Hattie Boulware and was called St. Matthew C.M.E. Church. In 1930, under the guidance of Reverend Leland, the group built a church at the corner of Leonard and Hay Streets. They again expanded in 1944 with a new building on the same location, pictured here. (Courtesy of Williams Memorial C.M.E.)

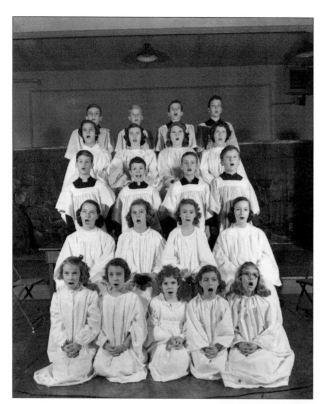

Almost every church has an adult choir and some have children's choirs. This 1949 photograph shows the children's choir of the Immaculate Heart of Mary Catholic Church. Dressed in choir robes, these 21 angelic voices sing hymns for the congregation. The church has a children's choir today. (Courtesy High Point Museum.)

In 1950, Immaculate Heart of Mary's pastor, Fr. Robert McMillan, allowed WHPE to broadcast a mass on the radio. The goal of WHPE, a radio station run by the *High Point Enterprise*, was to inform the public. When launched in 1947, Rev. Wilson O. Weldon of the First Methodist Church commented, "Progressive churches will be quick to recognize the value of radio." (Courtesy High Point Museum.)

The wedding of Judith Mendenhall Mower and Clifford Leith Goodman Jr. took place in the sanctuary of the fourth and current Springfield Meeting House on October 28, 1950. Traditionally, Quakers did not need a minister to celebrate marriage. Before World War II, it was common for a couple to marry during a regular meeting, reciting a prayer that would make them married. The congregation would witness the marriage. (Courtesy Springfield Memorial Association.)

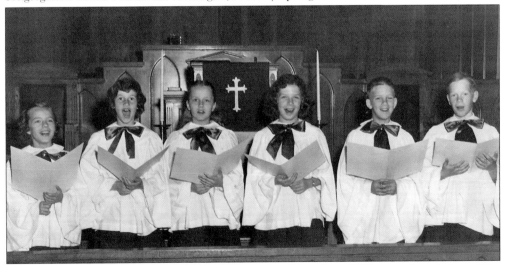

The youth choir members of Main Street Methodist Church in 1953 were, from left to right, Joan Wood, Jean Mason, Carol Kearns, Dawn Austin, Jim Morgan, and Dale Walker. Jim said his father was known for his beautiful singing voice; he, alas, for his enthusiasm and volume. (Courtesy Ann and Jim Morgan.)

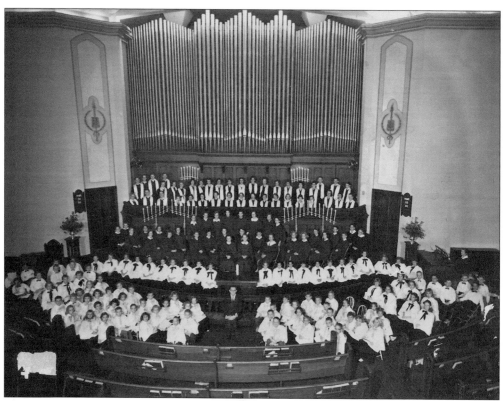

Pictured above is the sanctuary of Wesley Memorial Church as it looked from 1914 to 1960 while on Main Street. This 1958 photograph of the children's and adults' choirs was taken before the Christmas candlelight service. Howard Coble was the music director, and Wanna McAnally was the organist. (Courtesy Wesley Memorial United Methodist Church.)

Christ the King Church was started during the days of segregation as a black Catholic mission church located at the corner of Hoskins and East Kivett Drive. Today, it thrives as a model of diversity with a congregation that includes Colombians, Vietnamese, Koreans, Nigerians, Filipinos, Liberians, Indians, Mexicans, and Chileans, among others. (Courtesy High Point Museum.)

The ladies of the B'nai Israel synagogue would hold periodic "home beautiful" demonstrations for the general public. They would set a table for an appropriate holiday, here Hanukah, and invite the public to learn more about the Jewish faith and traditions. From left to right are unidentified and Betty Ann Ruden. (Courtesy B'nai Israel Congregation.)

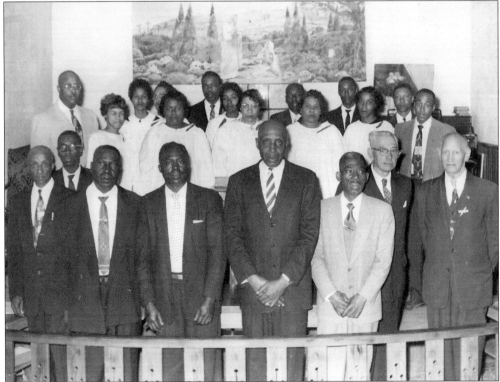

In 1970, St. Matthew C.M.E. Church changed its name to Williams C.M.E. Church in memory of Rev. William N. Williams, seen here on the left in the back row standing with choir members and church leaders. On December 14, 2004, Williams opened the new cathedral at 3400 Triangle Lake Road. (Courtesy of Williams Memorial C.M.E.)

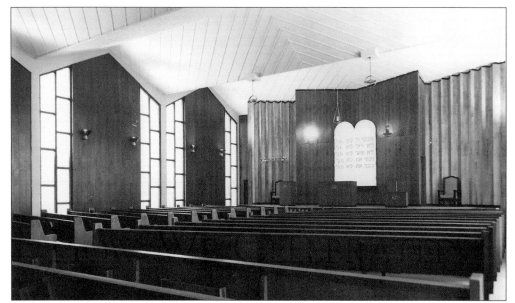

A new synagogue was built on property at Country Club Drive and Kensington Street. Local architect Robert Conner designed the three-unit building to serve the growing congregation of 89 families. The new synagogue was dedicated on November 7, 1965. The sanctuary today is virtually the same with the exception of different chairs and the addition of stained-glass windows. (Courtesy B'nai Israel Congregation.)

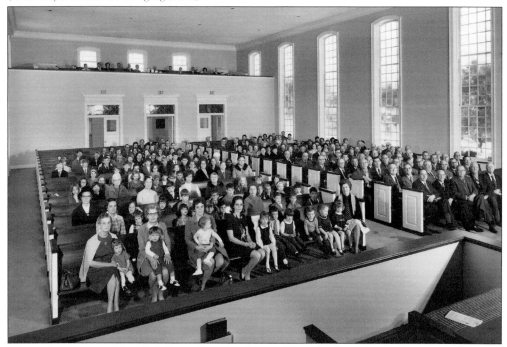

This is the interior of the High Point Friends Meeting House built on Quaker Lane. Purchased in 1949, the present meetinghouse was completed in 1956. This is the third structure for the High Point Friends Meeting House. Note that the men are segregated from the women and children. Until the 1870s or 1880s, services for men and women were held separately.

Five

How We Celebrated

Celebrations and milestones help residents to mark what is important. Families celebrate birthdays; holidays, such as Christmas or Halloween; weddings; and sometimes just get together.

Communities have similar celebrations, often marking milestones. One of High Point's big celebrations was the Pageant of Progress held in 1923 for the completion of the Boone-Wilmington Highway, Highway 421. Interestingly, though the road did not run through High Point, it was seen as a huge accomplishment and something that would make the lives of local folks easier as they traveled to the mountains or the coast.

Another milestone celebration, planned and talked about for years, was the 100th anniversary of the town—except not really. High Point became an official town in 1859, but High Pointers chose to celebrate the 100th anniversary in 1951 in honor of the day that they broke ground for the railroad. The difference of a few years did not seem to matter to them, as men grew their beards long as "Brethren of the Brush" and competed to see who had the longest beard. Ladies, the "Sisters of Swish," donned appropriate costumes in celebration. A parade was staged celebrating the many companies that were here. An elaborate play, *High Point, Then and Now*, was staged at Albion-Millis Stadium (for six nights running) to tell the history of High Point. At a time before widespread television and other distractions, it was well attended.

The following photographs capture many High Point celebrations and milestones.

Before the turn of the 20th century, having a photograph made was an important, though not common, event. It was a time to dress in the finest clothes and go to the photographer's studio where the pictures would be taken. This 1880s photograph of Joe Worth captures the style of the day, when young boys wore knickers and hair often grown long. As an adult, Worth developed the Brentwood neighborhood.

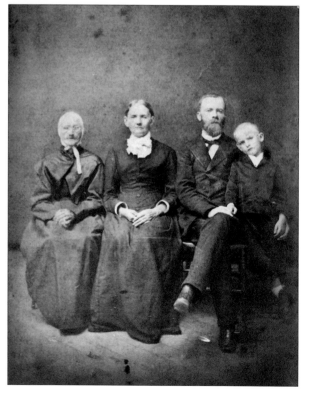

Four generations are pictured in High Point on July 25, 1882. From left to right are Mary Frazer, great-grandmother, age 85; Eunice Blair, grandmother age 58; J.S. Blair, father, age 35; and Joseph, son of J.S. Blair, age seven. (Photograph by D.L. Clark; courtesy Springfield Memorial Association.)

The first telephone switchboard used in High Point around 1900 handled 120 lines. In 1876, Alexander Bell invented the phone, and 22 years later, in 1898, Jesse F. Hayden organized the Thomasville Telephone Exchange with 45 lines in service. By 1900, he had acquired the High Point Telephone Exchange with 60 phones. (Courtesy North State Communications.)

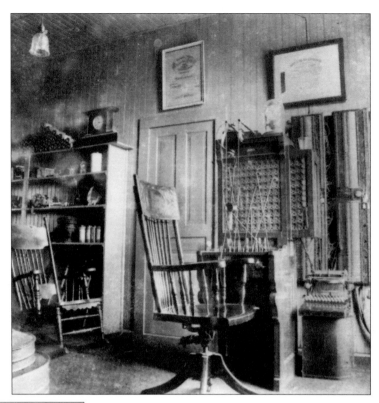

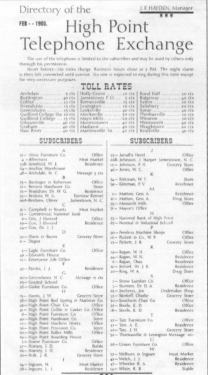

This reproduction of the High Point Telephone Exchange Directory from 1900 shows how many telephone lines the company served—approximately 73. George Matton, the druggist, secured the first telephone line for his residence, while the mayor's office was the 71st to sign up. Most of the telephone lines were for stores or offices, though a few individuals had telephones in their home. (Courtesy North State Communications.)

Walsie and Lillian Cable pose for their photograph at the High Point Fair in 1908. They were Michael Brown's great-uncle and aunt; he donated the photograph. They are not seated in a real car, but a prop with a backdrop curtain painted with the countryside. (Courtesy Michael L. Brown.)

The Pageant of Progress was held on October 25, 1923, to celebrate the completion of the Boone-Wilmington Highway, Highway 421. It was considered one of the best parades ever held by the city. Pictured here are the Pickett Building (left), W.A. Barber Printing (204 North Main Street, center), the Hiatt Tire Company (right). Note the painted Coca-Cola and Pepsi signs.

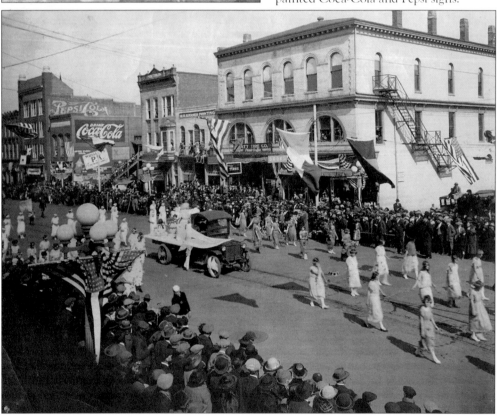

Mr. and Mrs. John C. Siceloff are riding in an open carriage with festooned wheels, pulled by a black horse, presumably as part of the celebration of the Pageant of Progress held in 1923. The J. Henry Millis home is in the background. J.C. Siceloff served on the finance committee for the Pageant of Progress. (Courtesy Paul Siceloff.)

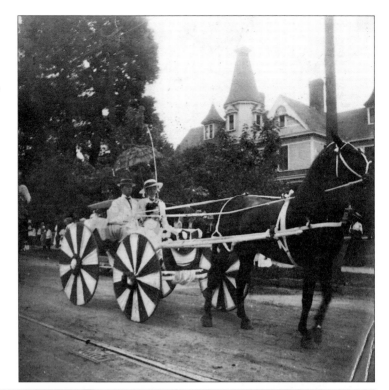

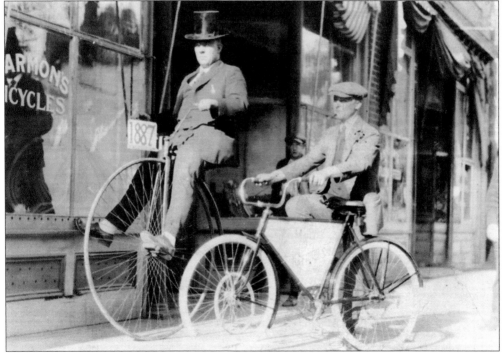

The 1923 Pageant of Progress featured early modes of transportation. Bicycles from different eras are seen here. On the left is a "penny farthing" named for the size of the wheels—the front the size of a penny and the rear a farthing (English coins). The other bike seems contemporary.

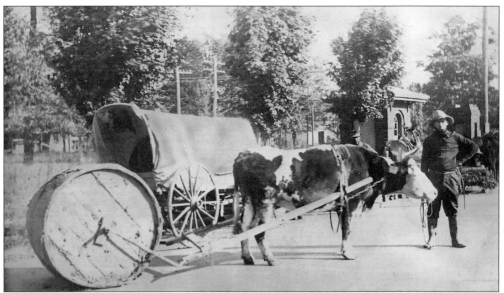

This is a tobacco hogshead that would have been pulled over the Plank Road to Fayetteville by oxen. The hogsheads were filled with tobacco, weighing approximately 1,000 pounds. This was one of many items in the Pageant of Progress. The covered wagon was also featured in the parade.

Pauline Simmons is pictured in front of a 1929 Dodge model DS sedan parked at the Tomlinson Home on Hillcrest Drive about 1929. As a charter member of the Junior Service League (now Junior League), she is posing for the "Follies." Pauline was also a charter member of the High Point Historical Society. (Courtesy Joan S. Garner.)

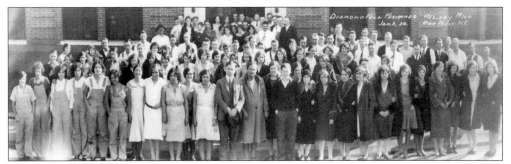

On January 3, 1930, the Diamond Full Fashioned Hosiery Mill celebrated the New Year. Earnest Gary Rice, a young man of 20, is in the fourth row, third from the left. He would continue his career in hosiery. Frank Wineskie was president of the company at this time. (Courtesy Ted and Barbara Rice.)

In 1935, Margaret Washburn Randle celebrated her sixth birthday with her friends. The birthday girl is seated fourth from the left with her cake in front of her. When Margaret turned 60, this photograph was sent to friends as an invitation to her surprise party. Rida Boyles, standing second from left, attended both parties. (Courtesy of Rida Ingram Boyles.)

This gathering of ladies includes, from left to right, Mrs. P.M. Davis, Lillie Reddick, Emma Blair, Annie Ellington, Ada Blair, and Esther Jarrell. It is believed to be a celebration of a birthday for the twin sisters Emma and Ada Blair. The sisters were two of eight children born to Solomon and Abigail Hunt Blair. (Courtesy Springfield Memorial Association.)

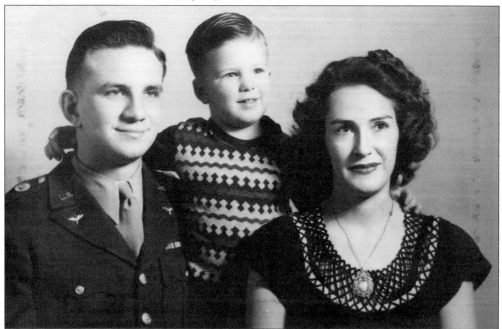

The August 1945 photograph of James V. Morgan, son Jim, and wife Dorothy Boudin was taken after J.V.'s return home from World War II. Morgan was an Air Force captain, serving near Casablanca and heading up security. In this capacity, he often communicated directly with Winston Churchill. Jim met his father for the first time at the end of the war. (Courtesy Ann and Jim Morgan.)

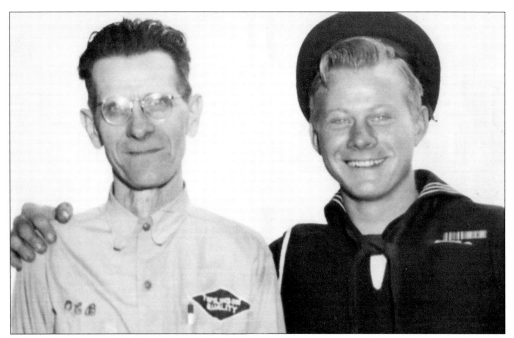

Cotton Brown surprised his father, O.C. Brown, at his workplace during World War II. His father was working at Tomlinson Furniture Company in 1945. The company took the photograph of the two, commemorating the happy homecoming. O.C. Brown was the grandfather of Michael S. Brown, who contributed this photograph. (Courtesy Michael Brown.)

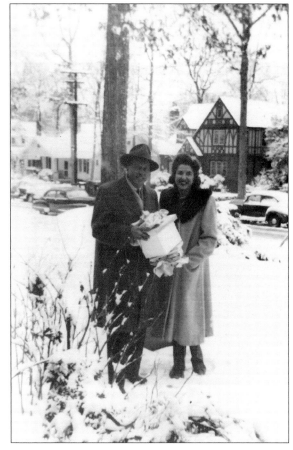

Married only three months, Billy and Pauline Siceloff carry a gift to friends living on Hillcrest Drive on Christmas Day 1947. They were married on September 26 at St. Mary's Episcopal Church. They would have three sons who would grow up in the house at 1039 Rockford Road that their father designed. Billy worked for Siceloff Oil Company and was the father of John Douglas, William Bruce, and Paul Raymond Siceloff. (Courtesy Paul Siceloff.)

In 1949, the *High Point Enterprise* ran this photograph of Emily Kester with her sons on Easter Sunday in front of South Main Street Methodist Church. From left to right are Tom, Gene (with the sun in his eyes), Buck, and Bill. Note the Hershey bar peeking out of Gene's pocket. The Kesters' owned Rose Furniture Company, a retail furniture store. (Courtesy Gene Kester.)

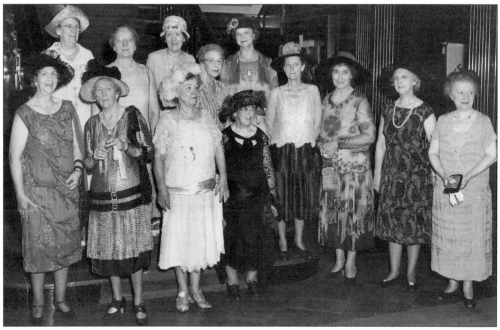

On September 17, 1924, a group of women organized as the High Point Garden Club under the direction of Bertha Snow Cox. It was the second club to be formed in North Carolina. On the 25th anniversary, the charter members (wearing vintage dresses from 1924) gathered at the YWCA (today, the J.H. Adams Inn) to celebrate.

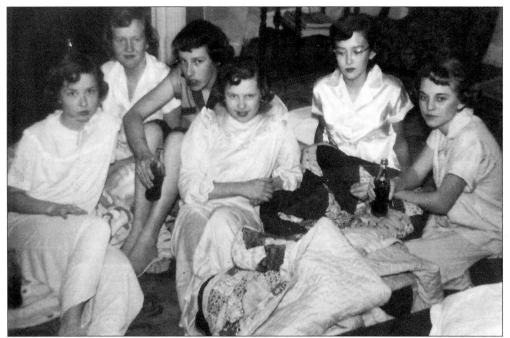

Slumber parties were a favorite activity among teenage girls. This was a pajama party on New Year's Eve in 1950 at Margaret Stewart's home. From left to right are Jackie Corn, Faye Kendall, Sandra Spencer, Mary Jean Tinsley, unidentified, and Patsy Swaim. Some of the ladies appear to be enjoying a Coke. (Courtesy Ann and Jim Morgan.)

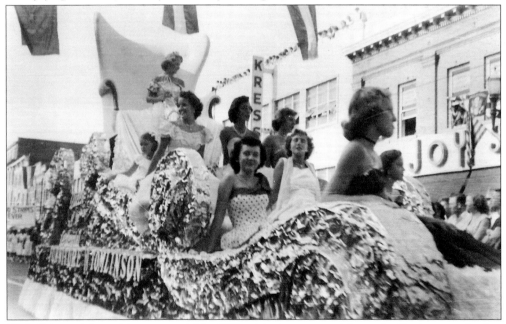

High Point celebrated its centennial in 1951 with the centennial parade. During a sweltering heat wave, throngs watched their favorite floats. The Tomlinson Furniture float was graced by queen Mary Lou Culler and her attendants. Her throne is the well-recognized Tomlinson chair called the Gainsborough. Today, it is on view at the High Point Museum.

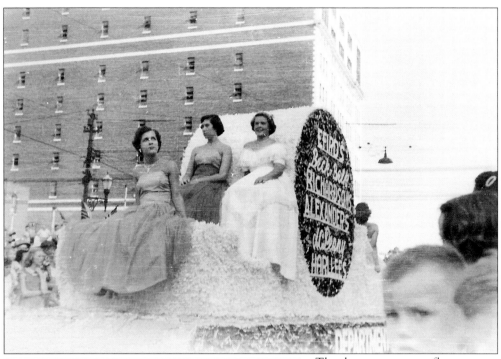

The department store float
featured a variety of shops
in downtown High Point,
including Efird's, Belk and Beck,
Richardson's, Alexander's, J.C.
Penney, and Harllee's. During
the centennial, many men
grew beards and competed to
see who had the longest. The
community also staged a huge
drama that featured 1,400 people.

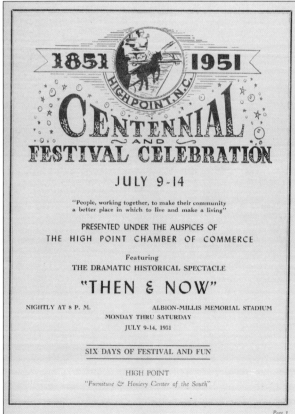

The front page of the 1951
centennial celebration program
shows a logo of a carriage on
the Plank Road crossing with
a train on the railroad. The
centennial was a successful
affair that included a pageant
called *High Point, Then and
Now*. It ran for six nights.

100

Christmas photograph cards became popular during the 1950s. One, from Jesse and Jim Millis, features their three children, Emily, Billy and Jimmy, waiting for Santa Claus to come down the chimney. Their grandfather was the founder of High Point Pants and Overalls, High Point Hosiery, and Adams-Millis Corporation. The latter was the first company from High Point traded on the stock exchange.

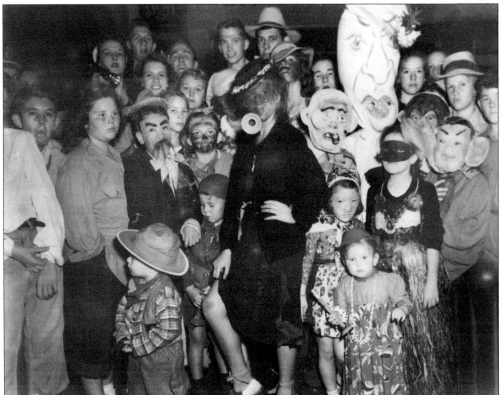

In the 1950s and 1960s, the High Point Parks and Recreation Department celebrated Halloween with an evening of fun and costumes. Children of all ages participated and created their costumes using their imaginations and whatever they had in their closets. Some elaborate masks were made or purchased; however, buying costumes of super heroes was not yet thought of.

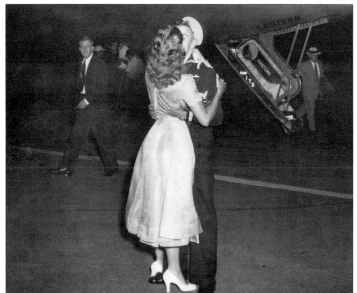

In 1953, Della Stroud was so happy to have her husband return from Korea, she gave him a welcoming kiss, reminiscent of the famous *Life* magazine cover at the end of World War II. This was at the local airport at a time when people were allowed to greet visitors at the gate. Note that the plane was flown by Eastern Airlines, now defunct. (Courtesy Della Stroud.)

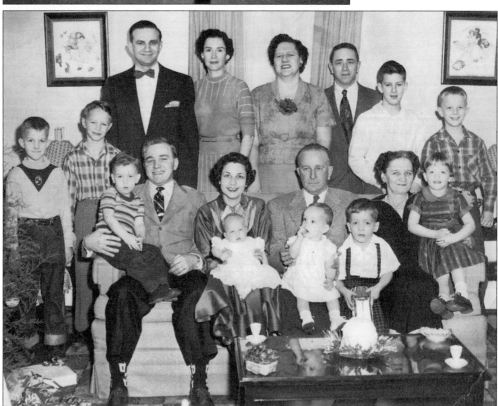

In 1954, the Morgan family gathered at the home of Virgle and Mable Morgan at 1300 Burton Street for Christmas Eve. Virgle and Mable, known as "Pawpaw" and "Mawmaw," are seated on the right side of the couch. Their three sons, Reitzel (seated left), J.V. (standing, third from left), and Raymond (standing, third from right) are pictured along with their wives and children. (Courtesy Ann and Jim Morgan.)

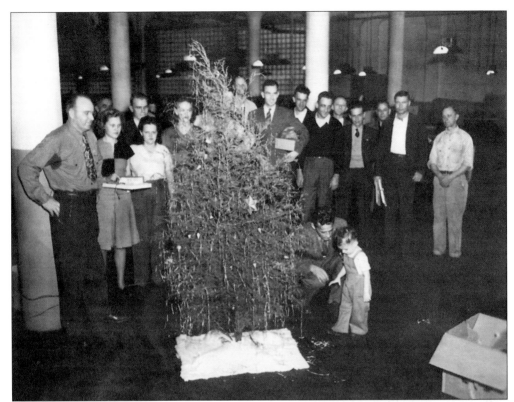

Like many companies, Adams-Millis held a Christmas party for its employees each year. Here, folks gather around a Christmas tree. Wade Russell, father of Linda Willard, is seen second from the right. He was a knitter for the company. (Courtesy Linda R. Willard.)

The North Main Street Skating Rink was the scene for a Halloween celebration. Della and Harold Stroud are pictured with their daughter Brenda. The ladies are dressed as Indian princesses. Harold worked as a printer. The skating rink is still the scene of a lot of action today. (Courtesy Della Stroud.)

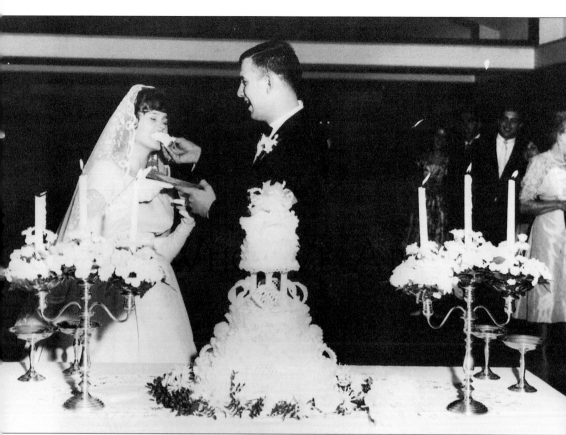

Ann and Jim Morgan were married on June 29, 1963, at the First Baptist Church. Their wedding reception was held at the former Emerywood Country Club with friends and family in attendance. After the cake was cut, Jim offered Ann the first piece, a long-standing tradition. (Courtesy Ann and Jim Morgan.)

Six

WHO WE ARE

High Point is a city of many people, traditions, and accomplishments. Some endeavors cannot really fit into any particular category but are part of who High Pointers are today.

Major projects such as the construction of the City Lake Dam and the development of neighborhoods are discussed in the following chapter. High Point also lowered the railroad tracks to enhance downtown traffic and keep citizens safe. It took two years to accomplish, and the trains ran on time throughout.

High Point's early residents laid the foundation for the strong government and thriving businesses that exist today. A young man came along who, through his music, moved the world and made High Point a recognizable location to many. Efforts to merchandise what has been manufactured in High Point have resulted in producing the largest "market" and event in North Carolina. This chapter also salutes a few high school students who showed great courage by silently sitting at a lunch counter so they could be treated as equal citizens.

High Point residents, as those of other towns, remember the places that once existed. They have seen churches, schools, and businesses come and go. Some buildings have been taken down and replaced with something residents hope will serve them better.

High Point is the culmination of all these people, their ambitions and desires, their vision, and their implementation of what they thought was best for the community. Together, this is High Point.

Absalom Franklin Jarrell, a brother of Noah and Manliff Jarrell, was the eighth of 13 children of Absalom Jarrell. He served in the Civil War in Company I, 22nd Regiment, of the North Carolina Troops but died on March 8, 1863, near Fredericksburg, Virginia, as a result of action. He was 24 years old. (Courtesy C.C. Conner.)

Elizabeth and Molly Brown, daughters of Absalom V. Brown of Browntown, are pictured here. He was one of the first incorporators and original commissioners of Browntown and was the first and only mayor. He was a blacksmith by trade. In the 1850s, he moved to High Point to help build the railroad. Interestingly, he was High Point's first town constable. (Courtesy Michael L. Brown.)

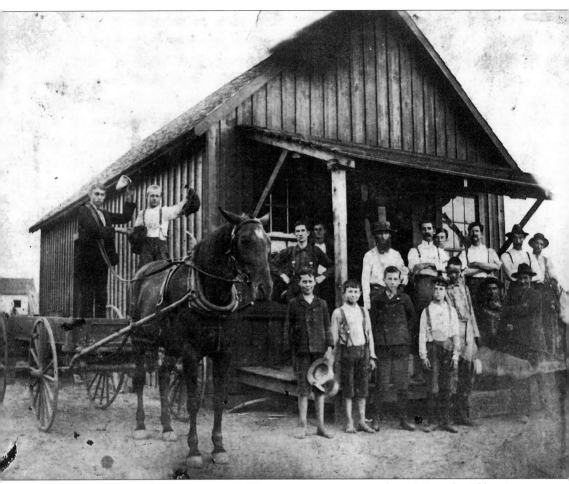

This rare c. 1880s image shows an area called Browntown, incorporated in 1842 in the Abbott's Creek area. The local townspeople are gathered in front of one of three known stores. At one time, it was said that 15 Brown families lived here. Today, there is little evidence that Browntown existed. (Courtesy Michael L. Brown.)

A family picture taken in the summer of 1943 shows Hazel Fisher Shipman (seated) and her four children, from left to right, Elizabeth Shipman Ennis, Hazel Shipman Erkel, Marion Shipman Wood, and William Gatewood Shipman. Willie went to UNC Chapel Hill on an athletic scholarship and was later killed in 1944 at the Battle of the Bulge. Marion is Richard Wood's mother. (Courtesy Richard F. Wood)

The children of Emma Jarrell and W.D. Simmons are seen in this c. 1910 image. From left to right are (first row) George Simmons, Frank Simmons (father of Joan Garner, photograph contributor), and Pauline Simmons; (second row) Mary Simmons, Emma Jarrell Simmons, and William D. Simmons Jr. Their house was located at 201 Elm Street. (Courtesy Joan S. Garner.)

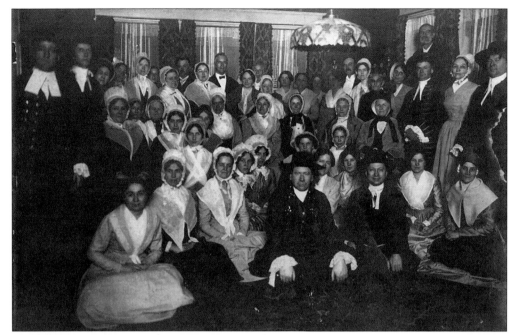

On November 16, 1911, a tea was held at the home of Mr. and Mrs. Jonathan Elwood Cox at 211 East Green Street. Quakers in the area attended wearing primitive Quaker dress that was on loan from the Friends of Philadelphia, many of the costumes being over 100 years old. J. Elwood Cox is standing in the back row, seventh from the right. (Courtesy Springfield Memorial Association.)

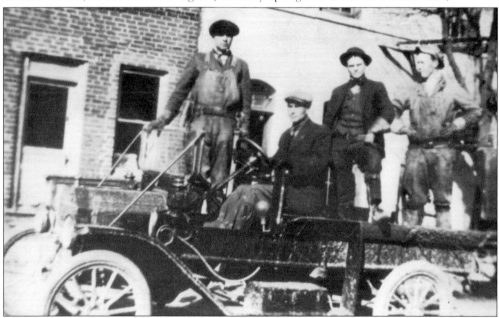

Since 1904, the Bell Company had been trying to get North State Telephone Company to sign a sublicensing contract, making the High Point exchange a Bell franchisee. By 1905, North State served about 325 customers. Between 1905 and 1910, North State organized area farmers into small companies that would build their own telephone lines. The first line construction truck is seen here in 1914. (Courtesy North State Communications.)

Linemen are stringing wire in the early days of North State Telephone Company. The first lines were made of iron wire and used to carry telegraph messages, but transmission was noisy and unreliable. Jesse Hayden began upgrading lines using copper wire, which cut down on the noise and maintained the volume of the transmission over a much greater distance. (Courtesy North State Communications.)

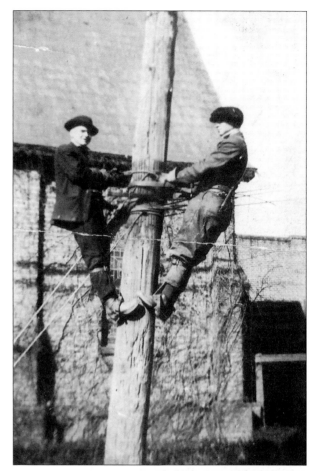

The family of Henry Clay and Jane Harriss Kearns are gathered on the woodpile at the family home at 408 South Main Street for this c. 1915 photograph. From left to right are (first row) Thurlow, Henry Jr., Jane, Henry Sr., and Cora; (second row) Edward, Gurney, James, Oscar, and Nan. Henry Clay was vice president of Kearns Furniture Company. (Courtesy Tom J. Kearns Jr.)

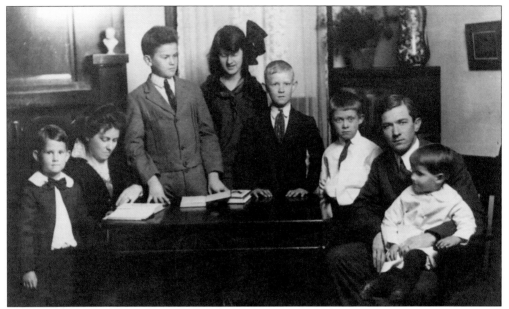

The portrait of George T. Wood's family includes, from left to right, Elliott, Bessie, George Jr., Josephine, Carl, Frank, George Sr., and Douglas. George went bankrupt in the recession after World War I. Bessie became the first female agent for Jefferson Standard Life Insurance, paying back all their debt. She helped George start the George T. Wood & Sons Company. They are the grandparents of Richard Wood. (Courtesy Richard F. Wood.)

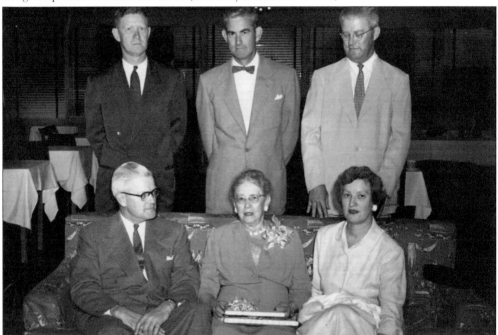

Celebrating their mother's 80th birthday on May 6, 1954, are, from left to right (seated) Dr. George Wood Jr., Bessie Sherrill Wood, and Josephine Wood Lyon; (standing) Carl Wood, Elliott Wood, and Frank Wood. The photograph was taken at the original Emerywood Country Club by Snow Studio. Bessie is Richard Wood's grandmother. (Courtesy Richard F. Wood.)

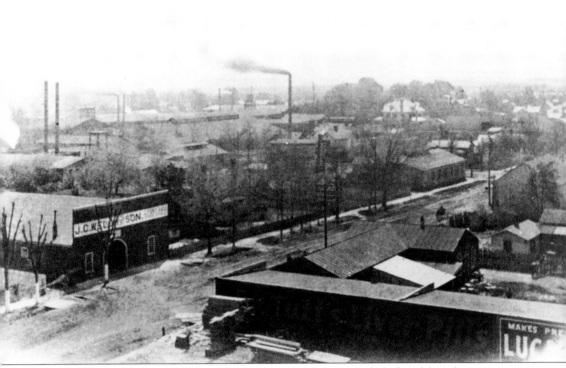

This c. 1913 view of High Point full of smokestacks was for many a symbol of wealth and prosperity. The city used the skyline of smokestacks on its "Welcome to High Point" sign. The original sign is on display at the High Point Museum. To the left is the J.C. Welch and Son livery stable at 129 Rankin Street (today, Wrenn Street).

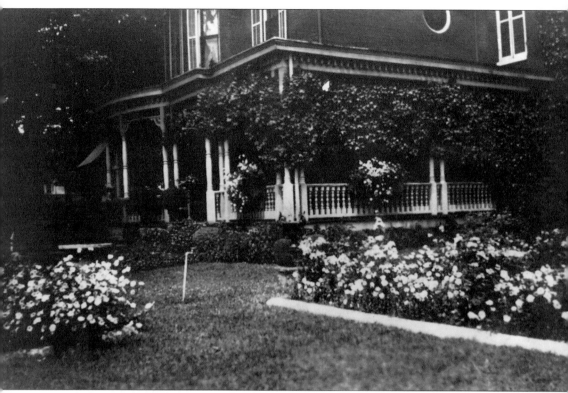

In 1855, J. Harper Johnston served the community as its first deputy sheriff. He lived in Jamestown until he moved to High Point in 1899. His house was located at 408 West Broad Street. Johnston was among the early residents of the area. This photograph shows the gardens at his home about 1920. (Courtesy Tom J. Kearns Jr.)

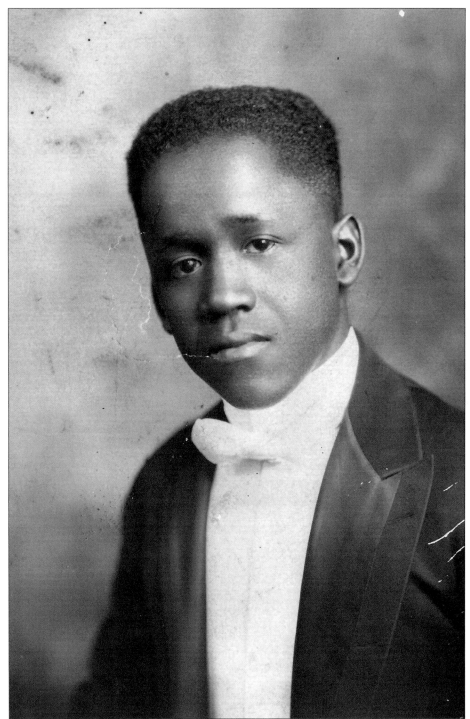

This portrait of Louis Bernard Haizlip was taken when he graduated from the Askin School of Embalming in Indianapolis, Indiana, in 1921. Born in Belews Creek, Haizlip located his business in High Point in 1924. His brother Paul, a student at William Penn, assisted him before and after school hours. Later, his daughter Lois would work with him. (Courtesy Haizlip family.)

This is a c. 1925 portrait of Celia London and Harry Doctor. She was born in New York City in 1900 and moved to High Point as a child of three. Doctor owned Vogue Cleaners on Main Street. He died in 1960 and she in 1975. They had one daughter, Anna Lou Doctor Cassell. (Courtesy B'nai Israel Congregation.)

Harrison Alexander and his family lived in this house, located at the corner of English and Elm Streets. In 1870, Alexander opened a store that carried dry goods, jewelry, millinery, and chinaware. Son A.E. and daughters Ida, Minnie, and Mary continued the business, closing it in 1979. The house with the columns is the William D. Simmons House, built in 1903.

Rev. M.R. Harvey, pastor of First Wesleyan Methodist Church, wrote "Tired of Mother" about an elderly lady who came by train to stay with her daughter in 1927. After waiting for hours, no one came to greet her. Being frail, she was taken to the hospital. When her daughter was located, she did not go to visit her mother. The mother died alone of grief.

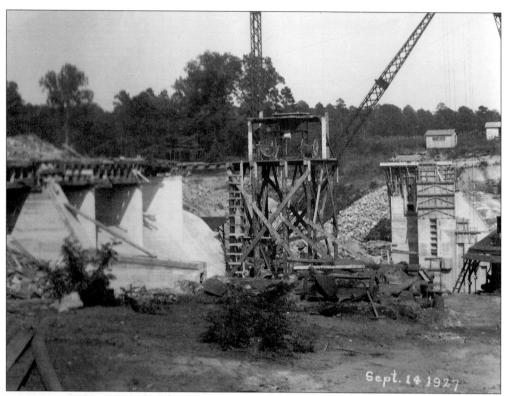

Sept. 14 1927

A reservoir for future water for High Point was under construction by 1927. The paper reported, "High Point is to construct a dam across Deep River near Jamestown which will create a body of water more than a square mile extent." Approximately 19 tracts were purchased to create the lake, and several buildings, including the 1767 James Mendenhall House, were destroyed.

The Grier Lowrance Construction Company of Statesville was awarded the contract to construct the dam for $332,800 and promised that hundreds of High Point people would be employed. Here, African American workers are seen digging through the "soft rock" that was encountered. It would be 1933 before people were allowed to fish in the lake.

Franklin Manliff Simmons is seen in 1935 taking a buggy ride with his horse Blue on the Simmons farm near Centennial and Eastchester. The son of W.D. Simmons, Franklin was involved in real estate like his father but also had the Pointer Service Station at the northwest corner of English and Elm Streets. (Courtesy Joan S. Garner.)

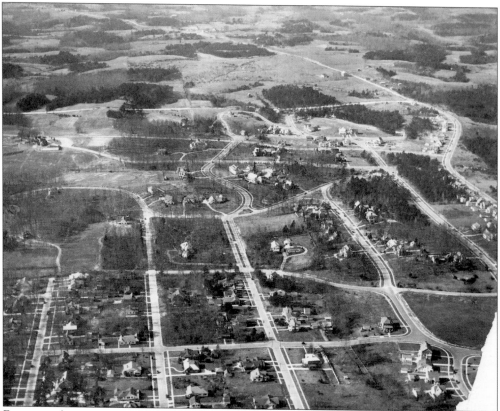

Emerywood was named for Emery A. Bencini, an executive with Snow Lumber Company, who planned to build a large home here. With his untimely death, his widow sold the property to Stephen Clark, who developed the area. Emerywood would feature large estates with landscaped settings. Premier landscape architect Earl Sumner Draper of Charlotte designed the development, planning winding streets with lush landscaping. The aerial photograph above was taken about 1930. One of the homes constructed was for Fred Tate, former mayor and owner of Continental Furniture, and his wife. It would later be named Kearnwood by Amos R. Kearns of Crown Hosiery. It was designed by Northup and O'Brien of Winston-Salem and constructed by R.K. Stewart. The landscaping was representative of Emerywood.

Bessie Wood lived in this house, built in 1912, on Boulevard Street. It sat across from the hospital, when the hospital was privately owned by Dr. Burris. It was said she kept a cow in the backyard. Brothers Carl and Frank Wood would milk the cow and take the milk to Dr. Burris each day. (Courtesy Richard F. Wood.)

An architect's rendering of the proposed Southern Furniture Exposition Building showed how the expansion would incorporate and attach to the former showroom structure. The old city hall was located on the corner of East Commerce and South Wrenn Streets and was razed for this expansion. The building was later renamed the International Home Furnishings Center.

During World War II, citizens were urged to plant Victory Gardens to help keep the public fed. Allen Welborn rented an acre of land for the duration of the war to grow produce and fresh vegetables. His wife would spend every summer canning produce for use throughout the year. (Courtesy Anne Welborn Andrews.)

The home of Bettie and James Edward Kirkman was at the corner of Washington (now Kivett) and Hamilton Streets facing north. Bettie (Hunt Sapp) was the daughter of Dr. A.J. Sapp, who took care of the smallpox victims after the Civil War. Kirkman was owner of the Giant Furniture Company. (Courtesy Pat Williard.)

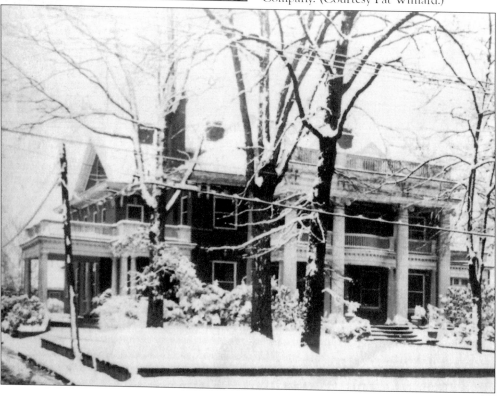

This aerial view of High Point in 1957 is looking north on Main Street. Located on the end of the second block is Wesley Memorial Church with the Sheraton Hotel following. First Baptist Church is on the other side of the street. On the far left of the photograph is the earlier High Point Hospital.

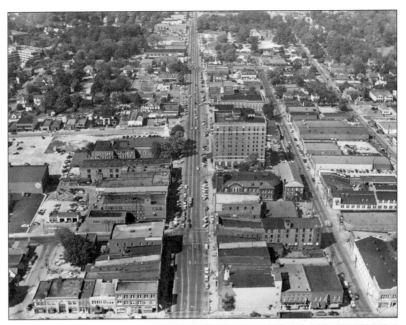

In 1963, Della and Brenda Stroud take time out to feed the ducks at Floral Garden Cemetery on West Rotary Drive. Note the styles of the 1960s. It was a time of big, bouffant hairdos as well as big bumpers on cars. Women and girls wore dresses, even for casual outings. (Courtesy Della Stroud.)

In September 1963, black students marched before white onlookers after being refused service near A&W Root Beer at the corner of North Main Street and Sunset Drive. High Point students began their protest on February 11, 1960, with a sit-in at Woolworth's. Rufus Newlin is on the left. (Courtesy High Point Museum.)

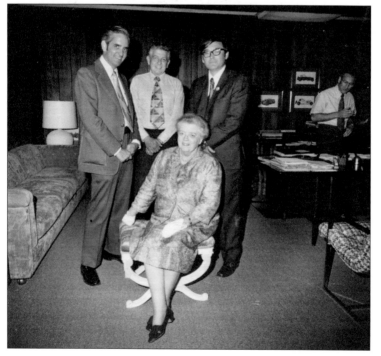

High Point was known far and wide as a furniture-manufacturing town. Here, about 1970, Frances Bavier, Aunt Bee of the Andy Griffith Show, is seen sitting on a stool she purchased with Jordan Washburn (left), Darrell Pierce (center) and an unidentified man from Silver Craft Furniture Company. At this time, people were welcome to shop at the factory. (Courtesy Mark Pierce.)

Jake Harris's Furniture House was open from about 1936 to 1985, located for many years in this Queen Anne–style house on East Washington Street. Harris was in the first Boy Scout Troop in High Point in 1912 and recognized in 1985 as the oldest native-born Jewish resident in High Point. He died in 1999 at the age of 96. (Courtesy B'nai Israel Congregation.)

A statue honoring High Point jazz musician John Coltrane was erected in 2006. Known internationally for his unique genre and style, Coltrane was raised on Underhill Street and attended William Penn High School. Thomas Jay Warren of Oregon sculpted the eight-foot-tall bronze likeness of Coltrane, which is in the northwest corner of city hall property at the intersection of Commerce Street and Hamilton Street. (Courtesy Jay Warren.)

BIBLIOGRAPHY

Briggs, Benjamin. *The Architecture of High Point, North Carolina*. Charleston, SC: The History Press, 2008.

Brown, Joe Exum. *A Compendium of High Point Retail Stores*. 2009.

Hill's High Point City Directories. Richmond, VA: Hill Directory Company, 1901.

Joyce, Mary Lib Clark. *Clark's Collection of Historical Remembrances: Collections and Recollections from Three Generations of Clark Historians*. High Point, NC: self-published, 1990.

Marks, Robert. *High Point: Reflections of the Past*. High Point, NC: The High Point Historical Society, Inc., 1996.

McCaslin, Richard. B. *Remembered Be Thy Blessings: High Point University The College Years, 1924–1991*. High Point, NC: High Point University, 1995.

Pierce, Michael G. *History of the High Point Public Schools 1897–1993*. High Point, NC: 1993.

Sizemore, F. J. *The Building and Builders of a City*. High Point, NC: 1947.

Smith, H. McKelden. *Architectural Resources: An Inventory of Historic Architecture*, Raleigh, NC: North Carolina Department of Cultural Resources, 1979.

Discover Thousands of Local History Books Featuring Millions of Vintage Images

Arcadia Publishing, the leading local history publisher in the United States, is committed to making history accessible and meaningful through publishing books that celebrate and preserve the heritage of America's people and places.

Find more books like this at
www.arcadiapublishing.com

Search for your hometown history, your old stomping grounds, and even your favorite sports team.